Lover's in Art

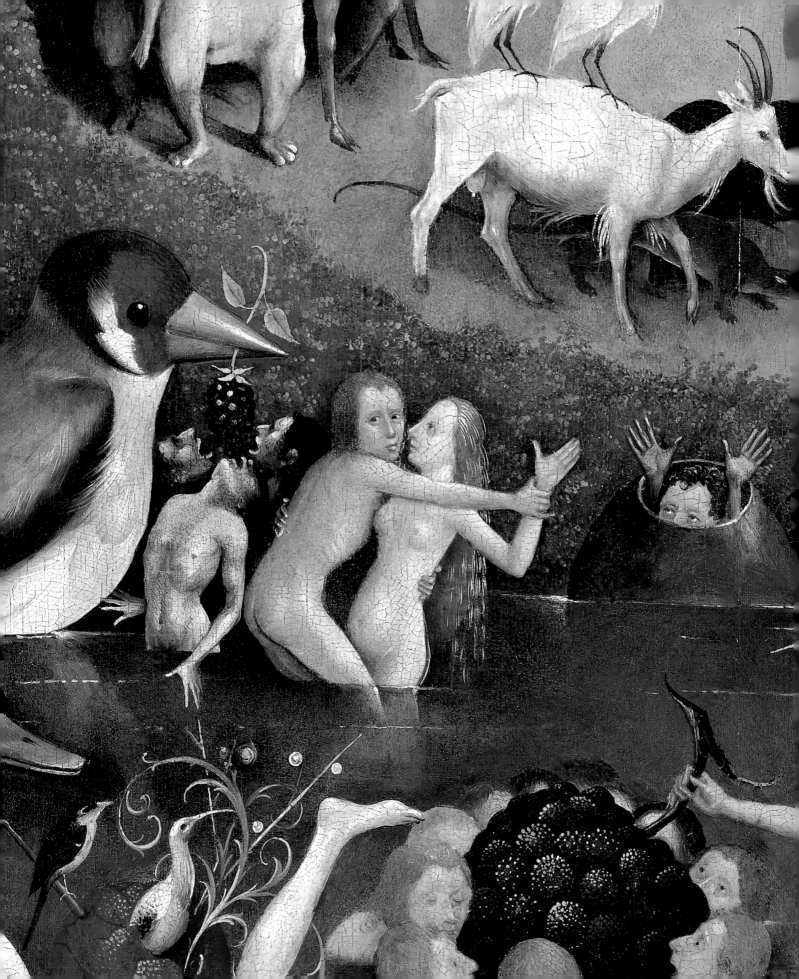

Sabine Adler

Lover's in Art

Prestel

MUNICH · BERLIN · LONDON · NEW YORK

Introduction

How do I love thee? Let me count the ways. Countless attempts have been made to capture this indescribably wonderful feeling in words, throughout the ages and all over the world. Browning's sonnet is just one of these. All of them try to distil the essence of what we generally understand by love – that feeling of romantic elation that makes hearts beat faster and cheeks blush redder, turns our legs to jelly and floods everything with radiant light, making us forget the drab everyday world and undermining any sense of reason. People who are in love are not of this world, they live in an alternative universe. And they would like to stay there.

But nature is against them, as biochemists and evolutionary psychologists drily point out. No state of elation can last for ever, and once the body has got over the euphoric hormone rush, we are rapidly brought down to earth again. And that is when the complications and disappointments begin – the higher you fly, the harder you fall. If we make everlasting romantic love the yardstick for genuine emotions, and one partner becomes responsible for the other's happiness, that is when pitfalls open up, and even couples who feel predestined for each other can stumble into them – together or alone, according to fate and circumstances.

This is often all the more tragic nowadays because romantic love has become the God of private life and money the God of public life in our increasingly secular society. So love is celebrated and transfigured as the highest ideal, exploited by the mass media, right down to the last little corner of the psyche.

It is generally felt that once the right partner has been found every existential need will be met

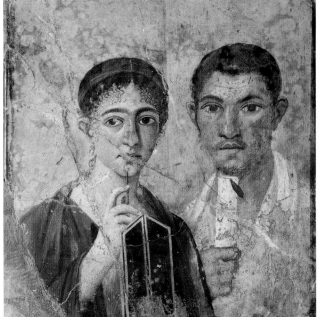

Anonymous, Roman
A Baker and His Wife,
1st century AD, Museo
Archeologico Nazionale, Naples

from then on – emotional, intellectual, sexual. Again, this is asking far too much of love, hence our constantly rising divorce and separation rates. In fact, romantic love and marriage make bad bedfellows. Approximately every third marriage leads to divorce, and the average tends to be higher in big cities. That is one side of the coin. The other side is rather more optimistic: almost everyone remarries, or at least gets involved in a long-term relationship – despite all the painful emotions and emotional miseries. The serial monogamy model has established itself firmly, and proved its worth. The marriage guidance counsellor and journalist Michael Mary asserts that since partners are supposed to love each other passionately, people now tend to change from partner to partner. They leave their longterm relationships and follow the call of passion. These two poles within a partnership, bonding and desire, are not satisfactorily compatible in the long term – and so we face a dilemma that had not existed in this form until now.

After this somewhat sobering résumé, we begin to wonder: can marriage be rescued at all? Of course it can – it has proved its worth as a survival strategy ever since man settled in his stone-age caves. The team always comes out better than the individual warrior. It doesn't matter whether you're stocking up with mammoth joints and dried fruit for the next famine, which is what you would have been doing 10,000 years ago, or accumulating capital or sharing out the tasks at home and at work, as you would today. Everything is easier with two people. And it's also easier to deal with possibly the most important element of marriage, producing offspring, if there are two of you. But children and accumulated capital can lead to violent quarrels if things go off the rails, so marriage has a fixed legal framework, unlike passionate love, which is based on nothing but two souls in deepest harmony. So marriage is an entirely reasonable business. Ideally it does include lasting romantic love, but you can be heading for emotional complications and the divorce courts if you demand that as a natural and inevitable concomitant.

The German poet Goethe pointed out that love is ideal but marriage is real and it is always dangerous to confuse the two, thus making a distinction that still holds good today. But Goethe blurred the issue himself with his *Werther*, a work that led young men into copy-cat suicides all over Europe: he introduced the idea of the love match, as opposed to marriage based on reason. These ideas had a lasting effect on the significance of love in social life as well as the suicide statistics. We will return to them later.

Marriage as it is understood in Western culture is an amalgam of ancient Roman, European and Christian influences. It has provided subjects for fine art

since ancient times. Here we have to make a distinction – as was also the case, socially, morally and culturally in each particular epoch – between pictures of weddings and married couples on the one hand and of pairs of lovers, usually mythological, on the other.

The oldest depictions of pairs of lovers are to be found in Egyptian and ancient Greek art. Here, from the late fifth century BC onwards, we find private scenes for the first time, representing the opposite pole to political and military themes. Aphrodite and Ares, the god of war, are shown playing the game of love – mainly on vases and drinking vessels. But although this association became a dominant pictorial theme, it was soon faded out. It was also a story of adultery, as Aphrodite was the wife of Hephaistos. Thus her liaison with the very much younger Ares is an early example of ageism – but it also shows a warlike figure being disarmed by beauty. And it was not only the gods who got up to these things: we also see satyrs and nymphs savouring honeyed delights and erotic dalliance on Greek ceramics. Peleus and Thetis as well as Dionysos' chariot ride with Ariadne became popular mythological themes for wedding portraits, which are a little more staid.

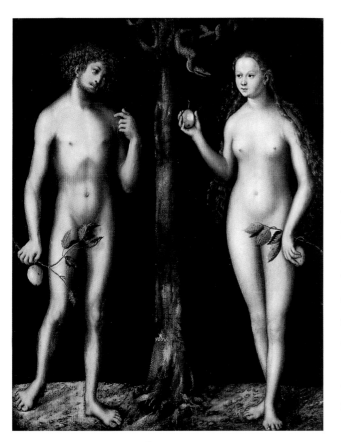

Lucas Cranach the Elder
Adam and Eve, c. 1513/15
Mainfränkisches Museum, Würzburg (on loan from the Fed. Rep. of Germany)

Depictions of loving couples also show a natural and relaxed attitude to sexuality in the Hellenistic and Roman periods. The refined arts of love and seduction were highly thought of in ancient Rome, and married women expected to see some evidence that their men had studied them. Indulging in desire and pleasurable physicality was seen as natural and beautiful. There was no claim to sexual exclusivity vis-à-vis a marriage partner. It was usual to have a concubine as well as a monogamous partnership, and this was seen as a legal sexual relationship between a man and a woman, though children from such marriages could not inherit. Divorce was also entirely acceptable and easily granted if both partners agreed that they had nothing in common, or that the mutual physical attraction was dead. This desire-based attitude to physicality is reflected in numerous wall paintings and relief ceramics. Prostitution is also portrayed – the brothel draw-

ings in Pompeii are the best-known examples. It is clear from portraits of married couples that men and women enjoyed equal rights. The sculptural designs on Etruscan-Roman sarcophagus lids convey a lively impression of the egalitarian relationship between man and wife that prevailed at the time. We see a loving couple in a life-long relationship, now waiting to experience something together in death, and exuding an almost sacred aura.

After the third and fourth centuries AD, art started to be rather less desire-friendly. Sexual reticence and moral austerity became a social maxim after Emperor Constantine's conversion to Christianity. Sensuality took a back seat, and nakedness in sculpture became less and less significant. As Evangelia Kelperi shows in her research on the naked woman in art, this also changes the way in which married couples are portrayed: "Thus on some sarcophaguses in Italy and Asia Minor marriage was shown as a spiritual union and not as a physical relationship. The wife stands or sits attentively in front of her husband, who is raising his right hand to emphasize a point. The contact between the married couple seems to have been broken off completely on a sarcophagus dating from the second half of the third century AD. The setting is rustic: on one side the pious woman is praying on her own, while her husband is engrossed in his studies. He has just stopped reading, and is pursuing a train of thought. The scroll is lying on the floor, rolled up. His head is raised, and he is looking into the distance as if he is having a vision. In this scene, which is typical of many marriage images of the day, the head of the family is no longer seeking contact with his wife. He is acting as a loner in life. It is intellectual activity in his rural seclusion that helps him to achieve a state of inner happiness. And so we are confronted with a view of life that equated philosophical contemplation and spirituality with happiness. The erotic component was eliminated from public art."

The anti-sensual tendencies of the late Roman period became even more marked in the Middle Ages. Pictures or sculptures that aroused passion or desire in the onlooker were taboo. If couples were represented at all, then it was only with close reference to the Bible or to scenes from Greek and Roman mythology, though in fact figures like Adam and Eve tended to be the principal protagonists, rather that Venus and Mars, satyrs and nymphs. And in addition to this, the gradual acceptance of the Christian concept of marriage subsequently had a great deal of influence on the understanding of sexuality and love.

The Church Fathers had been laying down theological guidelines for the interpretation of sexual and divine love since the fourth century – and had also placed strict limits on how the Adam and Eve story was viewed.

So the act of procreation was interpreted as a neutral union ordained by God – with no suggestion of pleasure or desire. The Church Fathers argued that Eve's fall from grace by eating the fruit of the tree of knowledge made men and women aware of their sexuality, and thus the helpless victims of their instincts from then on. Sexual love is therefore seen as impure and dirty. Women suffered above all from this new doctrine – they were written off as temptresses to acts of lust.

Early images of Adam and Eve, like nineth-century illustrations for Carolingian Bible manuscripts, for example, show them as asexual – following the theological line – each with hair of the same length. Thus they represent the natural condition before the fall from grace. The moment at which Adam and Eve are driven from Paradise represents the start of the division into male and female; this is not natural, according to the Church Fathers, but simply describes a momentary, unnatural condition for mankind. This asexual representation of men and women persists in medieval art until the twelfth century. It suggests that medieval man saw anything sensual as a threat to the salvation of his soul, while in ancient times it was interpreted as a natural and vigorous expression of the human condition.

There is another very important difference from the ancient world's perceptions that is crucial for the understanding of sexuality and love. In pre-Christian times a distinction was made between three forms of love – Eros as desire, Philia as friendship and Agape as brotherly love – but in the Christian canon only the model of Agape was taken on, and Eros and Philia were banished from the notion of love. A sublimated form of love, and thus hostility to sex, becomes a programme. Agape, as perfectly embodied by Jesus Christ, is seen from a theological point of view as cancelling out the sin of Adam and Eve.

But the High Middle Ages see love making a come-back. Man's need and longing for sensuality is taken into account again: courtly love, the highest form of romantic love, is invented. A clear distinction is made here between romantic love and marriage, as two mutually exclusive concepts. True love, says the notion that crystallized out from the eleventh century onwards, can exist only outside marriage. In the courtly tradition, that tremble-making sense of elation, that loss of control over heart and mind, can develop as the highest form of sublimation for the human sexual instinct relating to a woman who is married to another man. Thus sexual abstention was the prerequisite for passionate devotion of the soul. This meant that courtly love was not set on a collision course with Christian ideas of love, and required a high degree of morality – though making the fine distinction that the amorous knight's desire was directed not at

a goal in the next world, but one that was very much in this one. Romantic love, the Romance – all this starts with the *Roman de la Rose* (1230–40) by Guillaume de Lorris, in which the search for a rose is used as a symbol of a beloved woman. And the troubadours' love lyrics stand alongside love epics in promoting a return to sensuality in art and society. The relationship with the idealized beloved is made into something mystical in the songs of courtly love, love becomes immortal, as union with the beloved is unattainable, and passion does not touch the lowly spheres of everyday life. The historian George Duby says this on the subject: "One of the rewards of courtly service is that the lover was permitted to see the body of the courtly woman in secret in the intimacy of a closed room, when she was getting up or going to bed, and this permitted display, this rite of worship, this ceremony that was customary everywhere in the courtly world, had made the cultivated knight increasingly susceptible to physical charms." Whether the ideal and the reality were always one and the same is open to question – there is unlikely to be a record of whether a noblewoman yielded to her handsome minstrel's advances – or not.

Countless medieval book illuminations, panel pictures and tapestries show romantically inclined couples in a paradise garden, or *hortus conclusus*. It contains a well, flowers bloom, delicious fruit ripens, and the loving couple who are flouting the courtly rules are fenced off from the rest of the world. So these tender hours can be spent together only in a space that is separate from the rest of society. The courtly tradition plays an important role in terms of the way the sexes relate to each other – the woman no longer being a slave on the marriage market or a mere object of lust. She is transformed into the beautiful, unattainable beloved, and the man must subject himself to her will completely.

By contrast, a marriage was for maintaining a standard of living and producing offspring, for economic and reproductive purposes, in other words. This meant that the choice of partner was also a political and strategic act needing long preparation and diplomatic skills. Marriage was seen in the first place as a liaison between two families, and not two partners. It was a social link of the first rank, and forged important bonds that made families into allies in case of emergency or war.

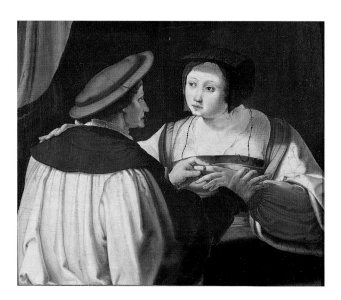

Lucas van Leyden
Engaged Couple, c. 1530
Musée des Beaux Arts, Strasbourg

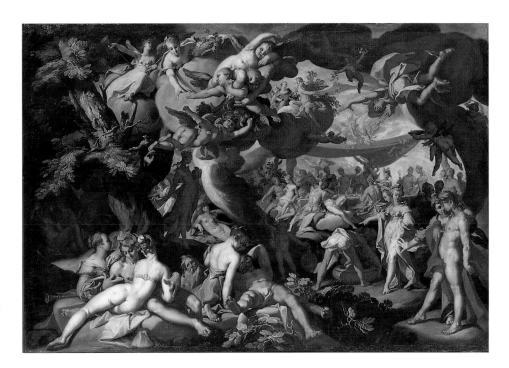

Abraham Bloemart
The Marriage of Peleus and Thetis
c. 1595
Staatsgemäldesammlung,
Alte Pinakothek, Munich

Before a marriage could take place there was a long period of mutual examination, leading to a confirmation of the status held by both the bridegroom's and the bride's father. Marriage was possibly only between those of equal rank. If it was thought 'seemly' or 'appropriate' to bring the two families together, a marriage contract was negotiated. The prospective bridegroom sought the approval of his male relatives, and then approached the father of the young woman he wished to marry. Daughters between thirteen and fourteen, later up to the age of twenty, were eligible for marriage. But engagement as a preliminary to marriage was possible even between children. The male relatives of the bride's family had to approve of the connection, as well as the bride's father. The level of the young man's gift to his fiancée was also negotiated before the contract was concluded. A dowry from the bride's side was a later addition.

Once the contract was concluded, the girl, who had no influence on the choice of partner herself, moved from her father's care to that of her husband to be. The marriage feast as an official confirmation of the contract then took place in the bridegroom's castle. The young man went forth, exacted his future bride from her father, and the two of them rode back to his castle. The girl left her own family at this point, and was accepted a part of her fiancé's family. The marriage feast was also the occasion on which the new spouse could be introduced as the rightful wife, and at the same time it saw as the start of the marital sharing of

house, table and bed. The marriage contract and the wedding feast established the bride as the future mother of legitimate children with a right to inherit. But the bride's parents and the bride's family did not take part in the wedding feast. As a rule the girl's parents did not visit their daughter's new home for six weeks, in order to see how she had been received by the bridegroom's family.

The choice of guests for the wedding feast and the splendour with which it developed emphasized both the political nature of the feast and the social status of the family. The available wealth was put quite openly on show, and if it was too much for the family's own budget, then the lord of the manor simply imposed an extra wedding tax. One example, quoted in Joachim Bumke's examination of court culture in the High Middle Ages details the marriage of Duke Heinrich of Carinthia married Adelheid of Brunswick in 1315. The old account books show that the following purchases were made: two ermine pelts, three gold-embroidered oriental fabrics for the bridegroom; furs of different kinds for fifty knights, scarlet fabric, 279 ells of green fabric; mixed fabrics and furs for the notaries; forty-six ells of brown fabric for the chaplains; 128 ells of red and green fabric for the female courtiers; further, thirty-one grain-dyed gold fabrics, twenty silk fabrics for battledress, other miscellaneous silks and linens, five wall hangings, nineteen tablecloths, towelling and a silk-covered tablecloth for the bridegroom. 10,000 gilded pearls were listed, and also many corals, 9,000 gilded buttons, ten hundredweight of wax, two hundredweight of pepper, fifteen hundredweight of rice, ten hundredweight of almonds, four hundredweight of grapes, 3,000 dates, seventeen hundredweight of figs, 215 talents of sugar, also sweets and spices, including fifteen blocks of saffron, nutmeg, cloves, cinnamon, ginger, raisins and galangal. The account books went on to itemize the provisions consumed at this wedding feast: sixty-nine dried beef cattle, 252 dried sheep, fifty-eight pigs, 357 pigs' shoulders, 242 lambs and kids, twelve geese, 185 chickens, 8,960 eggs, 2,995 cheeses, thirty-five bowls of fat, 55,560 loaves of bread and more than nineteen tuns of wine.

After the wedding feast came the important ceremony of the wedding night. It was treated as a public event. The relatives accompanied the young couple into the bridal chamber. They were led by the bridegroom's father, as *caput generi*, and called for God's blessing after the couple had been undressed. This ceremony took place in the evening, at a time that was considered favourable for love and reproduction.

Conjugal love – and that is the crucial difference from courtly love – is not seen as something that is necessary before a marriage, but something that may or

may not grow with time. In Andrea Capellenaus's treatise on love *De amore*, for example, written in France in the late twelfth century, it says: "I am still very astonished that you lay claim to the name of love for the conjugal inclination that all married people should feel for each other after the wedding. Surely it is obvious that there is no place for love between man and wife."

As there was no little or no choice of partner until the Council of Trent in 1563 – which introduced certain Church reforms whose effects are still felt in modern times – the practice of concubinage was entirely accepted. Here sensual attraction and affection could lead to liaisons that broke class boundaries. Long-term concubinage was tolerated socially, and women who lived in a steady, loving relationship with an upper-class man attracted no moral opprobrium as long as the rights and interests of the family were not deleteriously affected. Children born in a relationship with a concubine were defined as 'natural children', but unlike the offspring from a 'correct marriage' did not enjoy rights of inheritance. So the 'natural children' were dependent on the father's goodwill, but were often found appropriate professional positions after they came of age, or were married well. In some cases the wife and the concubines lived under the same roof, and their children were brought up together. But these forms of liberality related solely to the man's right to have an affair with one or more concubines: his unfaithfulness did not represent a danger in terms of purity of descent. Married women, however, were not allowed to indulge in such escapade.

As marriage was in the first place an act of power politics, the Church had little or no part to play at first in the marriage ceremony. The sacrament of marriage was not established until 1160. Once negotiations between the families were over, the liaison was fixed by a simple official contract, and with the exception of the marriage feast was not associated with any markedly religious or ceremonial rite. In the twelfth and thirteenth centuries the Church started to extend its influence and forbade so-called 'secret' or 'clandestine' marriages, which were partially heathen in origin, but based above all on the old Roman law.

According to the Roman legal code, it was not cohabitation but consent that makes a marriage. Two parties agreeing to share their lives was interpreted as *affectio maritalis*. This was not seen as a spontaneous emotion, but a continuing mental process supported by both partners. The lasting emotional tie was the essence of the marriage. If the *affectio maritalis* ceased, Roman law allowed a marriage to be dissolved easily. This practice was retained by the upper classes in the Middles Ages. But its legal status had to be confirmed by witnesses, usually members of the two families, who were present at the wedding. The couple publicly

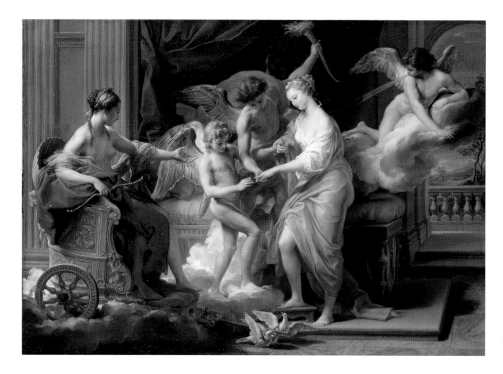

Pompeo Batoni
The Marriage of Cupid and Psyche
1756, Gemäldegalerie,
Staatliche Museen zu Berlin,
Preußischer Kulturbesitz

demonstrated their willingness to marry with a kiss, the joining of hands and the exchange of rings. Van Eyck made a clandestine marriage of the kind the subject of a picture in *The Arnolfini Marriage* (p. 31).

No major change was made until the thirteenth/fourteenth century. By then weddings were usually conducted by a priest. This passed part of the father's power to the Church. The priests established that the couple had agreed to marry, as bigamy was an occasional problem. Many promises were later broken, which led to considerable conflicts, and so the Church introduced the notion of banns. It also checked that the couple were not so closely related as to rule out a legitimate union. Due to dynastic and political reasons, incestuous unions were not uncommon. It was possible to circumvent the Church's ban on such unions by obtaining special permission from the Pope. The Church's requirements were generally treated in quite a lax way – the upper classes did not readily brook interference in political matters. Despite the Church's spiritual and temporal threats, clandestine marriage existed alongside the ecclesiastical ceremony until the 1563 decree. From then onwards, marriage was seen from a Christian point of view as an extension of divine love, connecting two souls on earth. This also made marital faithfulness into a fundamental basis for life-long companionship.

The model of marriage based on Christian elements and matters of family politics with the principal aim of ensuring offspring remained dominant in sub-

sequent centuries and underwent little variation. In the Italian Renaissance, in Venice, Florence and Rome in particular, some ancient ideas about love and marriage started to be reintroduced alongside the classical model. Physicality is strongly emphasized, sexuality acquires a new status and the nude finds it way back into art. The beauty of the body as an object of desire is celebrated as never before, above all in Italy. Here the revival of ancient mythological material offers a great deal of scope for expressing eroticism and sensuality. Venus as the goddess of love is depicted over and over again as the epitome of sensual beauty. The surface of her skin is soft and velvety, the gentle curves of her body are enticingly tactile, and the colours glow in intoxicating splendour.

The sensuality of the woman in particular is a striking feature of other mythological depictions of couples. Europe seducing Zeus in the form of a bull, Leda entering into a union with Zeus in the form of a swan, Danaë coming down on Zeus as a shower of gold – the possibilities for celebrating female beauty and shedding new light on relationships between the sexes are infinitely varied. Sources for these wide-ranging types of love are Ovid's *Metamorphoses* and also the allegorical novel of love *Hypnerotomachia Polifili* by Francesco Colonna, who turned his erotic fantasies against Christian sexual teaching and the treatment of antiquity.

Worldly couples, and rulers in particular, are shown decently and opulently dressed according to their status, with the exception of the women's deep *décolletages*. From the Gothic and Renaissance periods onwards, the portrait of a couple becomes an important document for the next generation, and thus acquires a genealogical function. One interpretation of the *Gotha Lovers* (p. 27) was that the painting was a bequest by a nobleman to his bourgeois mistress. She would be able to use the image as evidence of the union and thus make maintenance claims. The painting is also an example of the pictorial theme of the unequal couple. But while the Gotha couple are in fact portrayed as equals, showing great mutual affection, other variants take on grotesque and satirical traits. Differences in class or age, different characters or divergent expectations could be expressed in this pictorial form. In the double

Attributed to Michele da Verona, *The Engagement* (detail) *c.* 1490/1500, Gemäldegalerie, Staatliche Museen zu Berlin, Preußischer Kulturbesitz

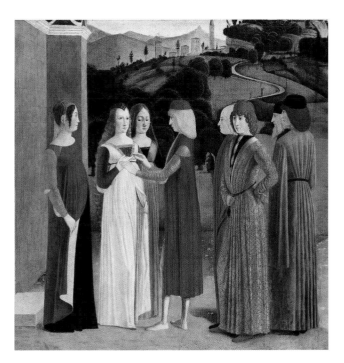

portrait of the Duke of Urbino and his wife Battista Sforza, dating from *c.* 1465 (p. 33), the genealogical aspect is joined by a philosophical one, which Piero della Francesca implements at the request of Duke Federico da Montefeltro, who was very keen on antiquity. It is only when male and female virtues are brought together that an ideal condition is achieved that also leads to a political Utopia. Liberation from higher authorities and emphasis on personal reason bring careful critical remarks about marriage into play for the first time. Lorenzo Lotto's *Wedding Portrait of Marsilio and his Bride* (p. 39) also shows marriage as a yoke that chains two people together like animals.

By contrast, Paris Bordone's portrait of *The Couple* (p. 41) shows the notion of the courtesan in Venice at its early stages. A new image of women had been created, again relating back to antiquity. Courtesans were successors to Greek *hetairai*, who know how to pamper men with their intellectual and erotic skills and earned their living in this way. This concept was revived, and the women were placed on pedestals. Venetian courtesans were highly educated women. Their interests included literature, and they knew how to entertain their admirers with learned conversation, music, song and dance. Unlike ordinary prostitutes, they usually had only a limited number of lovers and quite often married at a later stage. In Rome, and here above all at the papal court, courtesanship was treated very liberally. The ancient Romans saw sex as something to be enjoyed, according it a similar status to eating and drinking. It was not unknown for sexual orgies to take place in the Vatican. Upper-class wives were allowed the same sexual desires as men – provided that they remained faithful and subject to their husband in purely formal terms.

The sixteenth and seventeenth centuries introduced a whole range of new ideas about relationships between the sexes in the context of the Reformation and the return to Christian virtues it heralded. The introduction of marriage for priests by Martin Luther and Katharina von Bora was also an important factor. Michel de Montaigne, for example, returned to the ancient distinction between friendship, love and marriage, and came to the conclusion that only two forms were available to women here, love, and marriage. "Love for a woman is derived from our choice. … But if love is too much subject to the rhythm of desire, a 'flickering and fleeting fire', unlike friendship, this is destroyed by enjoyment, because its intention is physical and subject to satiation." If love turns to friendship, it "dwindles and flags", and may even create a desire for revenge. But marriage is "a deal that is free only until it is entered upon, as its duration … is dependent on concerns other than those of our will" and is subject to too many

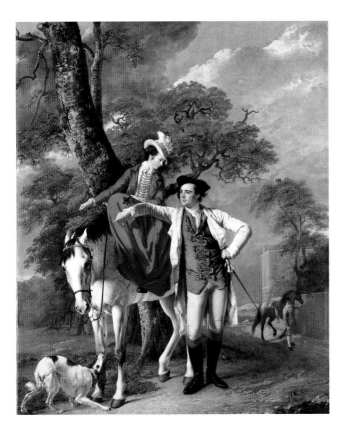

Joseph Wright of Derby
Mr. and Mrs. Thomas Coltman
c. 1770–72
National Gallery, London

influences. "And if it were possible", Montaigne continues, "to enter into such a free and unconstrained union, in which not only the souls were to find this complete enjoyment, but the bodies were also to have their part in the union, to which the whole being would be devoted: then it is certain that this friendship would be more perfect and fulfilled." (Phillippe Ariès/Georges Duby: *The Tale of a Private Life*). For Montaigne, friendship is more highly esteemed than love and marriage; he is referring above all to friendship between men. This is because he feels women are incapable of undertaking friendships, which fits in with his general view that the equality of the sexes had not made much headway.

Considerations of this kind have an influence on the broader view of marriage. The idea that marriage should be supported by comradeship and mutual loving support gradually established itself. This was new to the extent that sex in marriage was no longer seen as an act devoid of love and desire that was directed only at producing a male offspring. It was now supposed to provide something that had hitherto only been conceivable in extra-marital relationships: emotional love and sexual passion. Marriage was revalued, and marriage partners were seen as linked by friendship, sympathy and affection. This view was first found on a broad social basis in the Netherlands. Frans Hals's portrait of Isaac Massa and Beatrix van der Laen, Rubens with his wife Isabella Brant in the honeysuckle arbour (p. 47), Rembrandt with his wife Saskia (p. 51) – all these are famous pictorial examples of a new, happy and natural relationship between a man and a woman. At the same time, Dutch painting includes a large number of family portraits promoting morality in marriage and moral integrity as a basis for a stable social order. The same applies to the negative counter-image. There are countless images of wicked women hitting their husbands over the head with frying-pans, drunken wives neglecting the household or procuresses luring young women into having affairs.

Writing love-letters became fashionable. Vermeer, for example, returned to this theme again and again. Where the letters are not addressed to a lover but to

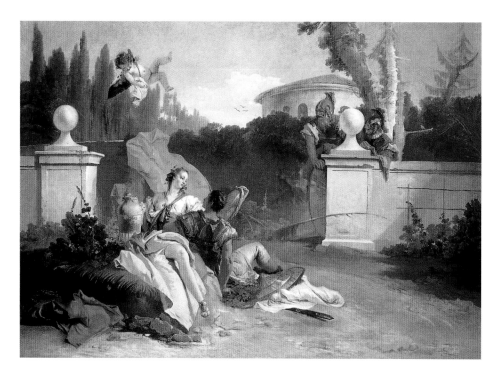

Giambattista Tiepolo
*Rinaldo and Armida in the
Garden*, c. 1742–45
The Art Institute of Chicago

one's own husband they express the new perceptions of partnership. For ex-
ample, in *The Tale of a Private Life*, Ariès and Duby cite a letter from a young
married woman from a noble background. She writes to her husband: "My dear
heart, I am happy to have the opportunity on this first day of the New Year to
renew the vow that I made to you: that I will love you my whole life long and
that my heart will cleave to no one in the world but you. I ask you, my dear
friend, to think of me, as every time you think of me you will find my thoughts
in you, and even if our bodies are parted, our souls will always be together."
Mythological couples also remain a dominant pictorial theme. So much pleasure
had never been taken in opulent flesh as in the work of Rembrandt and Rubens.

From the mid seventeenth century, Paris in particular saw the development of
a salon culture in which the relationship between men and women was redefined
in subtle intellectual dispute. The salon was one of the few places where women
could express themselves uninhibitedly. Here they could also meet the male sex
quite freely, and toy with a few amorous connections. The salons were places of
education for both sexes, and promoted the cultivation of politeness. As in the
High Middle Ages, mutual admiration followed certain rituals, and was not pri-
marily concerned with sexual relationships. On the contrary. The ladies in their
salons required gentlemen to restrain their instincts, which were categorized
as barbaric and inimical to understanding between the sexes. Women also

demanded sexual equality for the first time in their salons, and thus their right to be independent and acquire knowledge. They expected to be esteemed and treated with respect, and fought against the sexual enslavement of women in marriage. Madame de Scudéry, one of the most famous ladies with a salon, said on this subject: "One marries in order to hate. For this reason a true lover should never speak of marriage, because being a lover means desiring to be loved, and becoming a husband means desiring to be hated." Women saw giving birth as a particular imposition. This led to a serious suggestion that marriages should be dissolved after the birth of the first child. The child was to be handed over to the father, who would pay the woman a fee for having born it.

The ideas developed in the salons developed into Antoine Watteau's *fêtes galantes* in the early eighteenth century. Happy, affectionate couples disport themselves in the open air, expressing a new utopian order of society and the sexes, bound together in love (p. 55). Sensibility, and sentiment are seen as greater than reason. Where love flourishes, the barriers raised by class cease to be valid. Cythera, the island of love, for which the couples brought together by their tender bonds are bound in Watteau's famous picture, becomes the utopian symbol of a new and better society. In the work of Fragonard, love becomes

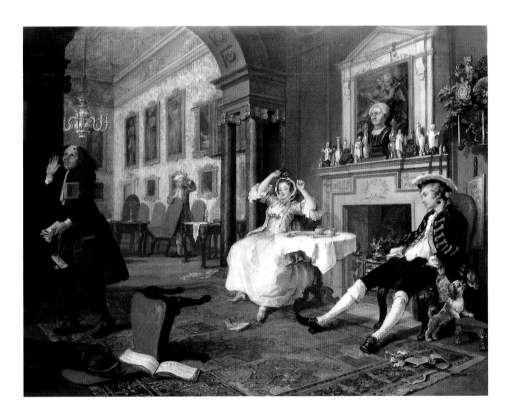

William Hogarth
The Tête à Tête
c. 1743
National Gallery, London

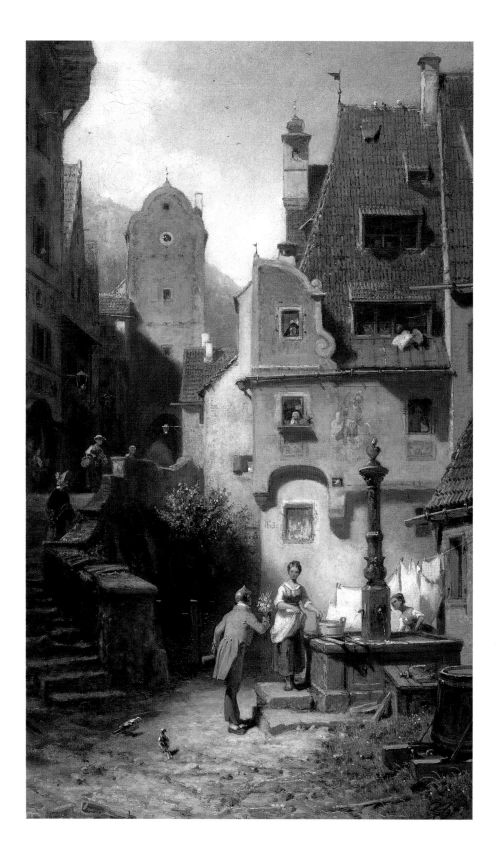

Carl Spitzweg
The Eternal Wooer
c. 1855/58
Private collection

dalliance: this adds a dash of spice to rococo society which is devoted to pleasure. Sexual practices in the late rococo are loose and simple. Women did not wear anything under their dresses, and everyone took pleasure at will – at least among the upper classes. After modern science had explained that human life was created by the union of two cells, the act of procreation lost its mystical dimension and is seen as something quite normal and banal.

William Hogarth reintroduced a moralizing and sharply ironic element to his scenes featuring couples. Couples exhausted by the act of love lose their tender expressions completely. Instead, Hogarth simply shows them in a state of dishevelment. In his 'Marriage à la Mode' cycle, he takes his attack on the bourgeoisie's seemingly ridiculous aping of aristocratic standards a little further. In the classical period, pictures of couples usually went back to mythological models, but in the Romantic period the theme acquires an entirely new look.

As a counter-movement to the decadence of the pre-revolutionary period and the interchangeability of partners in rococo times, the beauties of the heart were rediscovered in the late eighteenth and early nineteenth centuries. This was associated with belief that there is only one person who can make another person happy, and that he or she cannot be replaced by anyone else. This imposes a very high value on emotion – something that is played out particularly movingly in Goethe's *Werther*, as mentioned earlier. Werther was the hero of a book published in 1774 that made a major impact throughout Europe. The intensity of pain felt in unrequited love became the measure for large and genuine emotion. As a consequence, the marriage of reason, which had proved its worth over the years, was replaced by the postulate of the love marriage. From now on, heart is to come to heart, and free choice of partner is the supreme maxim. This contains potential for conflict, as class-appropriate marriages and true emotional inclination are frequently incompatible. When a decision has to be made between duty and affection there is always any amount of material for bourgeois tragedies and dramatic themes like Romeo and Juliet, as in the work of Delacroix, for example. And so the Romantics demand that noble conventions and small-minded bourgeois morality should be dismantled, and proclaim free love. Caspar David Friedrich's depictions of couples (p. 65) fit in with these new ideas. Man and woman relate to each other in natural, relaxed poses, and are usually seen amidst nature, away from the rigid social practices of urban life. The work of artists like Carl Spitzweg show a humorous slant on the heart's desire and the failure to achieve it because of the vagaries of everyday life. The idea of two hearts in harmony can also be taken to the level of a fairy-tale. Scenes of

romantic, weddings duly appeared – scenes that still resonate today.

The Victorian period pushed the Romantics' dream of free love back into the realms of pragmatism. Men's and women's roles were clearly divided up. The husband was responsible for business life, and the wife for the household. At the same time, Puritanism reintroduced the idea that pleasure is sinful – which led to middle-class double standards. The husband went to the brothel and the wife consoled herself with romantic weepies in the weekly illustrated magazines. Wedding couples are very rarely painted from the mid nineteenth century onwards – except in regional art and naïve painting. Instead the painter and his model become a popular subject, as a counter-image to rigid middle-class morality. The theme of the couple does not gain new impetus until the late nineteenth century. The early days of the women's emancipation movement redefined the roles of the sexes. In artistic circles in Paris, and even more so in Vienna, the theme of free love is discussed, and marriage is questioned as an institution that restricts people in their freedom to develop freely. Sexual freedom for women is in demand, along with their right to be involved in public life. Free love is celebrated as never before – as in the work of Gustav Klimt (p. 73), for example. But women's confidently asserted sexuality is stigmatized as demonic and terrifying, even to the extent of women being depicted as man-murdering sphinxes. Conflict and open warfare between the sexes arising from questioning traditional patterns becomes the predominant theme. Husband and wife can no longer understand each other, and no longer seek each other out. This view of life is reflected in numerous Modern works – in Edvard Munch, for example, Pablo Picasso, George Grosz or Max Ernst. Egon Schiele depicts sexuality as a source of torment, because it, too, can no longer bridge the gender gap (p. 75). The theme of the couple becomes peripheral in art after 1945, but homosexual partnerships are addressed for the first time – in the work of Gilbert & George from the seventies onwards, for example. The individual shifts to centre stage.

The pictures in this book present a survey of relationships between couples from the Middle Ages to the present day. They reflect man's constant longing for an emotion that has still lost none of its fascination – despite all the theories and the weight of cultural pessimism.

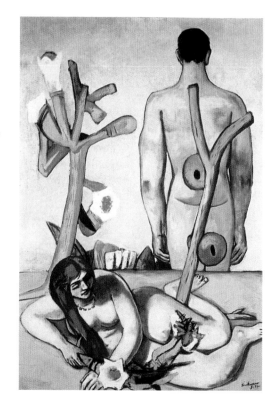

Max Beckmann, *Husband and Wife*, 1952, Private collection

Plates

The Wedding of Mary and Joseph

There are not many weddings in the Bible, so very little Christian narrative is available to artists. In the Old Testament, affairs of the heart are dealt with in a humane and worldly way. Adam and Eve are created for each other, but driven out of Paradise with clothes to wear, but no wedding ring. They are kept together by the work that they now have to do in order to survive. King David falls in love with Bathsheba, who is married to someone else, and seduces her. Before this love can become a marriage, the legitimate husband has to be got out of the way. This happens, and David has to suffer for it for a very long time. Potiphar's wife is obviously bored by everyday married life. She repeatedly tries to lure Joseph into a relationship, and goes about this very directly. Joseph manages to escape from her clutches, but the spurned woman takes a violent revenge. She simply turns the facts round and accuses Joseph of trying to seduce her, and her enraged husband throws his alleged rival into jail. Samson falls in love with a Philistine woman, and she agrees to marry him, but then betrays him in a wager and is finally promised to someone else by her father. Samson does not fare much better with Delilah. He is betrayed again – and also robbed of his superhuman strength – because he tells Delilah in a moment of amorous weakness that the secret of his strength is that his hair has never been cut.

In the New Testament, unions are usually reserved for the next life: single men and women who do not want to marry, wherever you look. The obstinate Barbara, for example, whose father locks her in a tower and punishes her with loneliness and isolation. But this does not bother her in the slightest, and certainly does not drive her into the arms of an earthly husband. Or Agnes, who feels she deserves a nobler and worthier husband than the one her father has chosen for her. She is sent naked into a brothel as a punishment for her refusal; she is supposed to lose her virginity, but an angel rescues her.

Apart from the wedding at Cana, the marriage of Mary and Joseph is one of the few stories that is available for painters to use on this theme. Giotto has captured the elderly Joseph's wedding to the very much younger Mary for the Scrovegni chapel with a great deal of psychological sensitivity. Mary is shown as a shy but desirable young woman with a number of admirers. The wedding ceremony is preceded by two scenes from Mary's life showing a group of young men presenting branches to the priest Abiatar. The prophecy tells that the branch belonging to the man Heaven has chosen for Mary will blossom. In the next fresco we see the suitors kneeling before the branches and fervently praying to be the right one. Joseph, the outsider, is chosen. The young men are disappointed, and Giotto shows this clearly in the expressions and gestures of the group of men on the left of the marriage fresco. One appears to be waving the event away almost contemptuously, another is breaking his branch. Joseph is placed in the centre of the picture, holding the blossoming branch, on which a dove is sitting, in his left hand. He is putting the ring on Mary's finger with his right hand. The depth and seriousness of the facial expressions and the kindliness with which the High Priest Abiatar is joining the couple's hands show Giotto's originality: he is able to give the figures an emotional immediacy that speaks directly to the viewer.

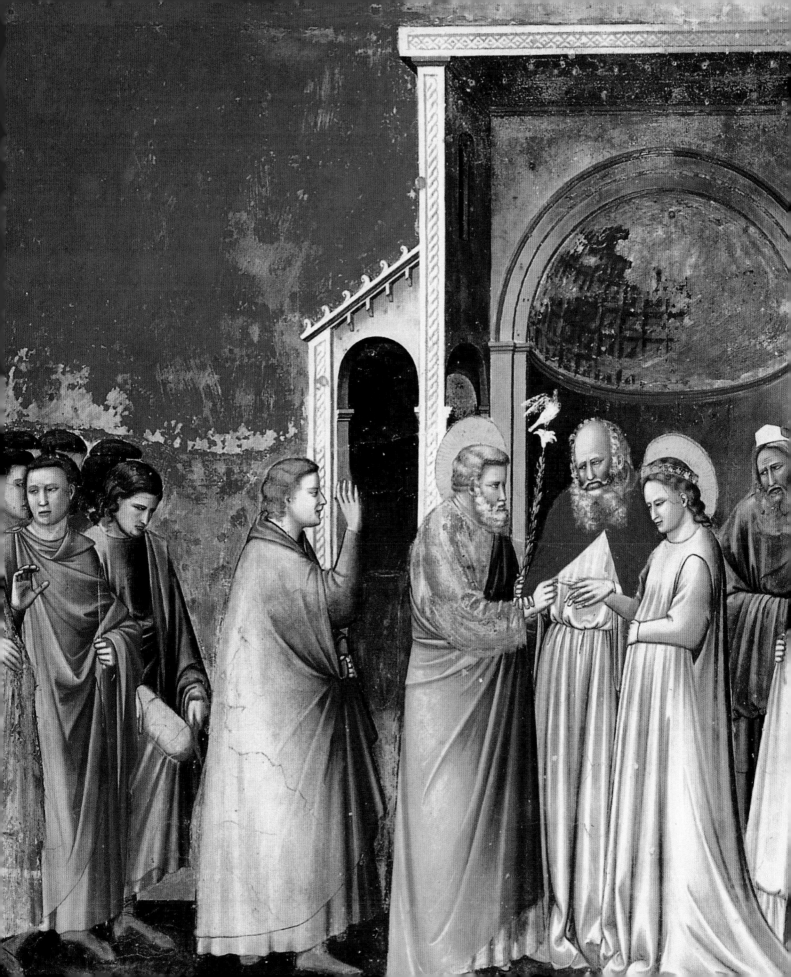

UNKNOWN MASTER
Gotha Lovers

A youth garlanded with wild roses, in expensive clothes. He is gently embracing his beloved and looking at her dreamily. The young woman – also dressed in magnificent fabrics – has lowered her eyelids, and her cheeks are blushing slightly, like the boy's. She is holding a small rose in her left hand, and fastening a golden band set with pearls to the young man's fur-trimmed cape with her right hand. The intimacy of the moment, the profound affection, the couple's grace and beauty are touching even at first glance. It must be true love. This stylized and idealized panel painting, dating from 1480/85, is seen as the classical pair of lovers in old German art. It has been in the Schlossmuseum in Gotha since the mid-nineteenth century. Much thought has gone into establishing who painted it and who the two people in the picture are – a married couple, or a pair of courtly lovers in the best medieval tradition.

A garland of flowers, a ring, or the so-called 'Minne-schnur' – the cord of courtly love – are gifts from a high-born woman to the nobleman who is courting her. Fixing the 'Schnürlein' – the band in this case – as a symbol of the lovers' attachment is central to the picture, and the boy's garland of flowers also links up with the tradition of courtly love. True love leading to marriage – which is taken for granted at a modern wedding – was seen as a contradiction in itself in the Middle Ages. Marriage was a political act between two families, not between two people. But true, refined love took place outside marriage and in secret, often symbolized by the walled *hortus conclusus*.

Did the person who commissioned the picture choose the courtly love motifs because he wanted to set up a monument to his great, secret love? Or is this a marriage portrait of the kind commissioned from the fifteenth century onwards as a record for the family tree? The inscriptions on the loosely floating banderoles and the coat of arms solve the riddle.

"Un byllich het Sye eß dedan
wan ich han eß sye genisse las.
Sye hat üch nyt gantz veracht
Dye üch das schnurlin hat gemacht."

"She did it unlawfully,
but I cared for her all the same.
She did not despise you completely
And made this 'Schnürlein' for you."

The relationship between the two lovers is wrong, unlawful and thus not befitting their social status. But nothing other than the inscription suggests a difference in social class. They are shown as equal partners, both in their expressions and gestures and also in their costly clothing. Research on the coat of arms has shown that the young man must be Philipp the Younger of Hanau, whose first wife was Countess Adriana von Nassau-Dil-lenburg. There is no second family coat of arms, which suggests that the woman in the painting is not of noble birth. It is probably Margarethe Weißkircher, who was of bourgeois origin, and lived with Philipp in a quasi-marital relationship after his wife died. Unlegalized cohabitations of this kind were not unusual in the fifteenth century, and were tolerated. Philipp must have loved Margarethe very much to have commissioned this picture by an unknown master. The choice of motifs relating to courtly love to express of true romantic love speaks volumes here, and so does the format, which is unusual for this type of picture: both the lovers are painted almost life-size.

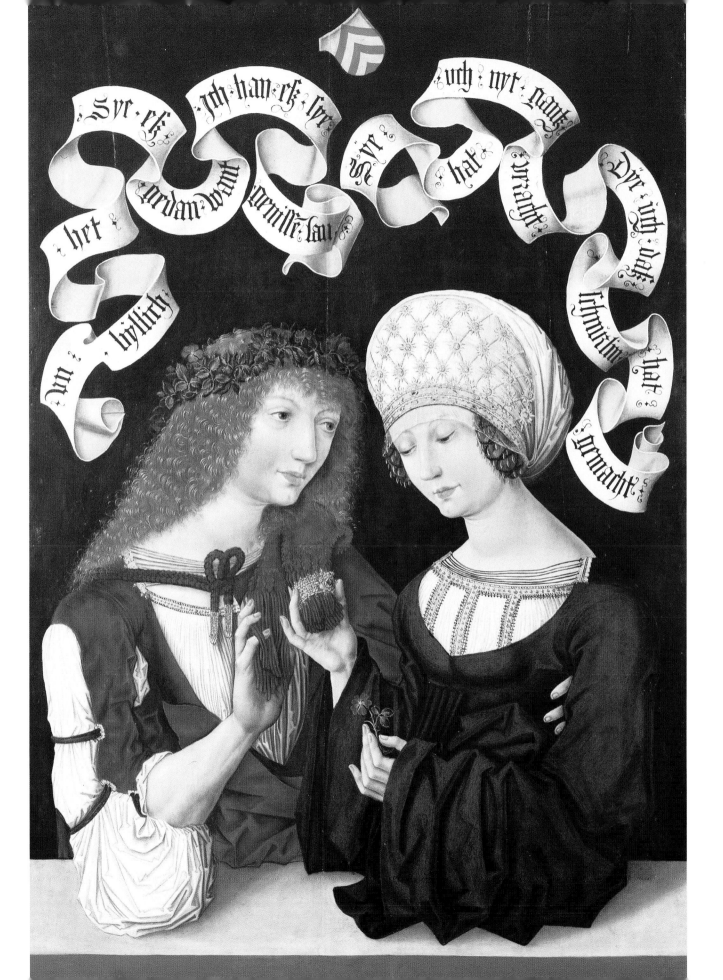

ANTONIO DEL POLLAIUOLO

Daphne and Apollo

An early summer's day in the south. The sky is a breezy blue, the air is full of the fragrance of laurel and the song of the cicadas. A young man has fallen most horribly in love, and his desire is so great that he forgets all the rules of flirtation. He is running to put his arms round his beloved's waist, who is running away as fast as she can. She neither wants nor is able to share such passion, and the only way she can think of to get away from her importunate suitor is by changing herself into a laurel bush.

The young god Apollo did not court this unrequited passion entirely by chance. He had killed the python-monster, and then scoffed in his male victor's hubris at Cupid, who came along with his arrow, bow and quiver: "What's all this, wanton boy, such a brave weapon for you, ... that only our shoulders are fit to bear, we who wound our game and wound our enemies with equal sharpness!"

Cupid is much annoyed by all this boasting, reaches into his quiver and shoots a gold-tipped arrow into Apollo's breast, who immediately loses his heart to the nymph Daphne. She "would fain flee, and is shy of the man"; she loves only the lonely forests, but she too is smitten by Cupid's arrow. Unfortunately, this one has a leaden tip, which makes her impervious to Apollo's stormy feelings. A wild seduction begins: "Both the god and the mortal woman are swept away by fear and desire. But the pursuer runs faster, as if borne on Cupid's pinions, and denies her peace: he is already close on her heels, panting into the flying hair on the nape of her neck. Now, her strength ebbing, she turns pale, weary with the work of this winged pursuit..." In her desperation Daphne appeals to her father, the river god Peneus, for help. He puts her beyond the young man's amorous grasp by turning her into a laurel bush.

Pollaiuolo captures the dramatic climax of the story from Ovid's *Metamorphoses* on a small wooden panel. Probably this painting adorned a Florentine chest or kitchen cupboard. Daphne's arms have already turned into a tree, but she is still all woman in her beauty and bodily charms. The god's mini-tunic, trimmed with costly jewels, allowing us a sense of his beautiful body underneath in the same way that Daphne's slit green garment reveals hers, gives the picture a high erotic charge. The couple's finely modelled legs, depicted with anatomical precision, show Pollaiuolo's profound interest in the human body. He was one of the first Renaissance painters to dissect corpses out of scientific interest and to use the knowledge he gleaned in his painting. This love story is not quite over with the disappearance of the beautiful Daphne. Apollo is sporting about his erotic defeat. He plucks a twig from the laurel bush, makes it into a victory wreath and decrees, as the god of the arts, the bow and of medicine, that in future all artists should be decked with laurel in memory of the beautiful nymph.

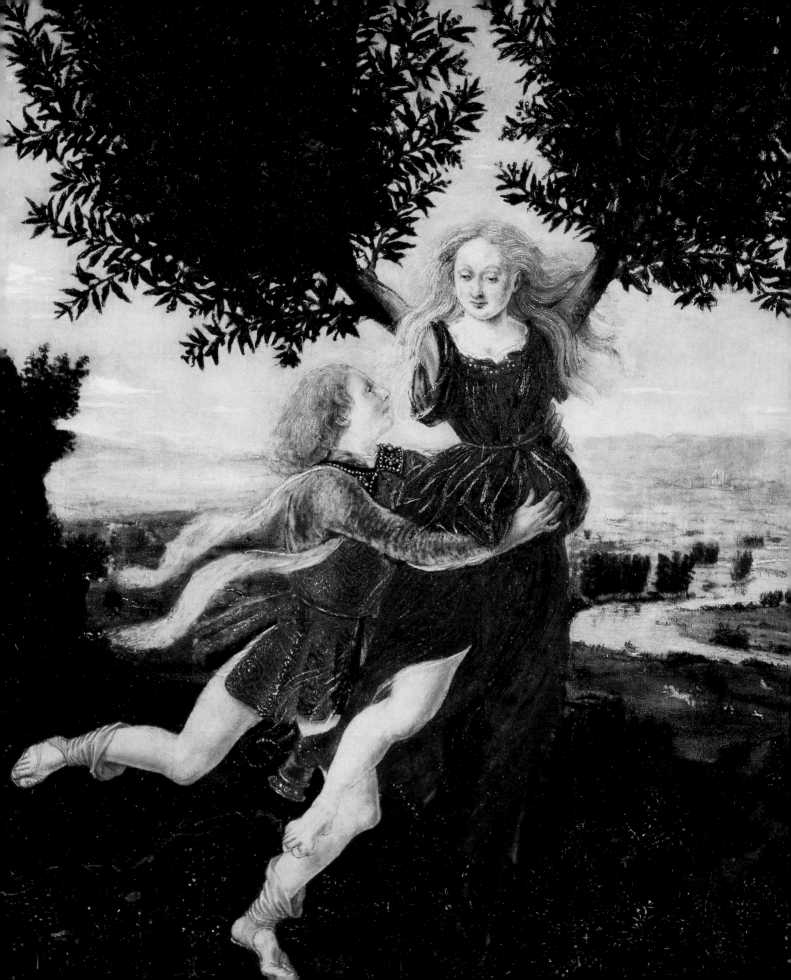

JAN VAN EYCK

The Arnolfini Marriage

If you want a quick, unconventional wedding today you fly to Las Vegas and hire a wedding dress and a morning suit off the peg for an hour. Love's gamblers make their arrangements in a special office there, say a quick 'I will' in the wedding chapel and then go back to the gaming tables to challenge Lady Luck, along with their fellow fortune-hunters. There are no elaborate preparations for a reception; friends and family send their best wishes from a distance. There are no wedding guests in Jan van Eyck's double portrait, there is not even a priest. But two people are still swearing that they will be faithful unto death. Surprisingly enough, the scene is set not in a church or chapel, but in a private room. The daylight is bright and warm, and the wooden floor, carpet and the expensive crimson fabric on the furniture give an impression of comfort and security. We are witnessing a very intimate moment. The wooden street shoes, worn as a protection against the dirt, look as though they have just been taken off and left where they were. It's summer outside, there is fruit on the cherry-tree, and the sunlight casts shadows on the window frames and in the rest of the room.

A man dressed in black, no longer in the first flush of youth, with finely chiselled features, a striking hat and a cloak trimmed with sable is raising his right hand to make his wedding vows. His left hand is holding the right hand of a young woman in a green dress, gathered very fully above her waist in the fashion of the period. A small dog – symbolizing marital faithfulness – is standing between the couple. They are the prosperous merchant and cloth dealer Giovanni Arnolfini and his bride, Giovanna Cenami. Both come from Lucca, in Italy. Arnolfini had settled in Bruges as a successful businessman and so was a stranger in Flanders. The bridal couple's families must have been many days' journey away when the wedding ceremony took place. This presumably explains the absence of wedding guests.

Intimate weddings conducted in places other than churches were entirely usual until the Council of Trent in 1563. Until then, there were church ceremonies, but also so-called clandestine weddings, which could be held in private, without the presence of a priest. Such marriages were recognized – and this is what we are seeing here. There are two witnesses, the painter himself and another person, neither of whom is immediately obvious. They and the bridal couple can be seen in the convex mirror. Above this is a clearly legible inscription – 'Johannes de Eyck fuit hic' – an unusual signature, written in a script that was mainly reserved for legal documents at the time. For this reason, the lettering and indeed the whole picture have been interpreted as a document witnessing the wedding. The attributes arranged in the room also leave no doubt that a private marriage contract is being sealed here. By the bridal bed is a small statue of St. Margaret, the patron saint of birth. The mirror is surrounded by ten scenes of the Passion, and these, along with the string of pearls hanging on the wall, symbolize the purity of Mary and thus the innocence of the bride. Even though it is broad daylight, a candle is burning in the candelabrum, representing the bridal candle that was carried before the bridal procession at public weddings. Van Eyck takes great care to make the faces and gestures eloquent: a wedding is an intimate and solemn ceremony. For a moment, the world seems to be holding its breath and standing still.

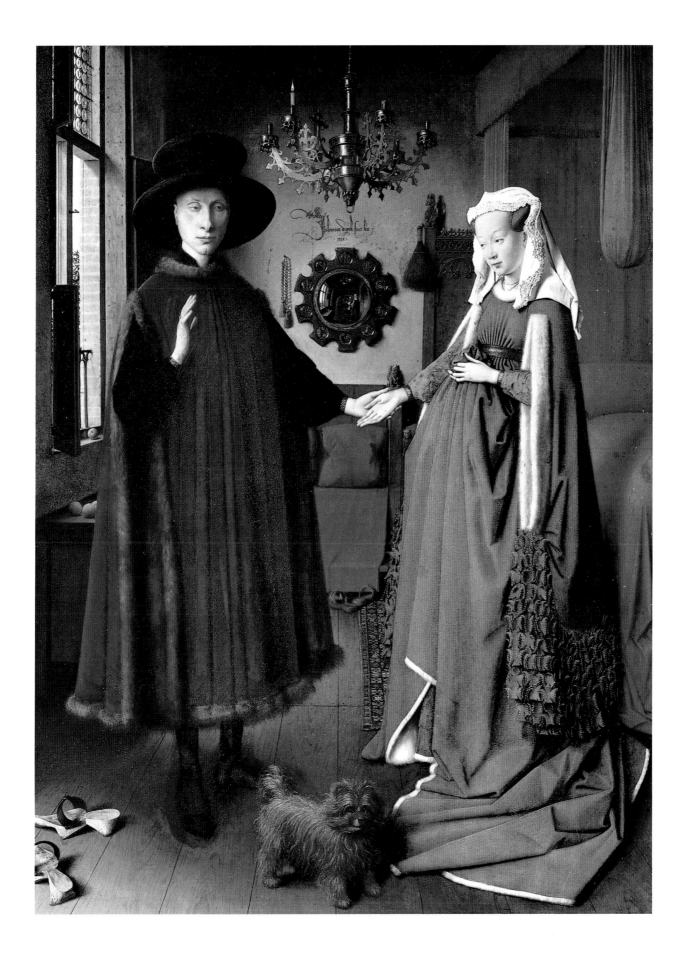

PIERO DELLA FRANCESCA

Federico da Montefeltro with his wife Battista Sforza

An intimate moment. Although these portraits are painted on separate panels, the background indicates that the sitters were painted to face each other, turning sideways on to the viewer. Piero della Francesca stages the double portrait of Federico da Montefeltro, Duke of Urbino, and his wife, Battista Sforza with great solemnity, tectonic rigour and classical, timeless simplicity. The figures are larger than life size, and placed against the landscape background in sharp profile, like the heads on ancient coins. Each figure has its own pictorial space, and they are portrayed as equal partners. This is a diptych, a format that was traditionally reserved for sentimental subjects. But the abstract elegance and the formal striving for order and balance objectivize the sentimental tone, and the emotion is played down in favour of a higher, overarching idea.

The notions put forward by Roman Stoicism suggested that man and woman became rounded human beings and complete personalities only through marriage. The aim of marriage is the symbiosis of the couple, who are self-sufficient and thus acquire peace of mind, happiness and freedom. To this extent it is certainly no coincidence that Piero della Francesca portrayed the couple as detached from the world, contented and well balanced.

The Duke himself may well have suggested this. Montefeltro was a man of broad education and a successful military commander. He was also an expert on ancient texts, which he read in the original, and asked scholars to provide commentaries on them. His court in Urbino attracted intellectuals from all over Europe.

He is assumed to have commissioned the diptych after the early death of his wife, who died while giving birth to a son. The Duke must have been greatly saddened by her early death. The choice of the literary model for the pictorial programme on the back of the portraits supports this: it was Petrarch's 'Trionfi' (1352). This allegorical and didactic poem is made up of six triumph narratives. The first deals with the triumph of love, the other with themes such as the triumph of fame over death, and of eternity over time. The triumphant progress of love in particular was a popular motif in the Renaissance and appeared in marquetry work on many bridal chests.

By asking for the triumph of love to be portrayed – both carriages are steered by Cupid – the Duke is invoking the power of love and at the same time the dissolution of all reality into eternity. The formal borrowing from ancient medals also made it possible to define the characters of the subjects more precisely on the other side of the picture. The four cardinal virtues bravery, moderation, justice and wisdom are sitting on the Duke's triumphal carriage, and on Battista's are the theological virtues of faith, hope and love. Battista is shown reading – an expression of her contemplative and decorous way of life. The Duke, contrastlingly, appears as a successful commander crowned by Victory.

So what is being shown here is more than the private world of a ruler and his consort. It is also a political programme: marriage as a microcosm of a new society based on ancient ideals.

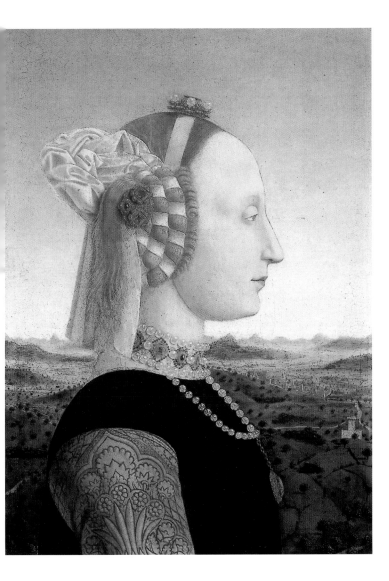
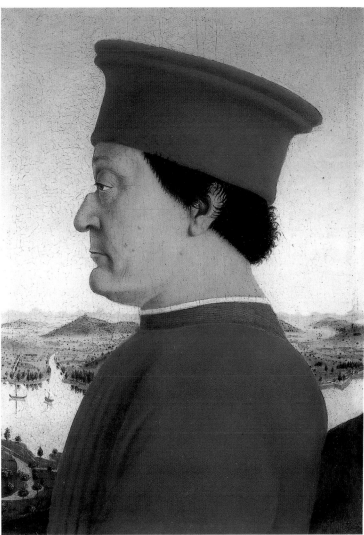

QUENTIN MASSYS

The Banker and his Wife

A man is doing his job. His wife is not by the fireside looking after the children, nor is she doing the washing – she is sitting instead at his side and watching him carrying out his everyday tasks. He is a money-changer and, as such, a predecessor of the modern banker who slips on his blue shirt and grey pinstripe suit each morning and then drives in a top-of-the-range car to one of the coolly glittering skyscrapers that are the twenty-first-century cathedrals of the banking industry. In Quentin Massys' oil painting, the world of work and the private sphere are still the same. The money-changer's office seems warm, harmonious and tidy. The table is covered with green felt and the tools of his trade, and there are books and scrolls on the shelves. A carafe and a chased plate suggest prosperity. The orange as a symbol of original sin and the string of beads repre-senting the purity of Mary imply a pious life.

The painter endows the couple's body language with harmony and profound sense of understanding. This is an ideal image of a marriage that guarantees security and loyalty after the first flush of love is over. It does not occur to us that this couple could quarrel. Every-thing in this painting is balanced, precisely weighed up in terms of composition and colour. The collars and cuffs of the clothes are trimmed with fur, the waists are belted, the hats match. The positions of head and hands in particular relate to each other precisely – the man is holding the scales with the same grace as the woman is turning the page of her prayer-book. She has stopped reading, and turns her attention from contemplation to everyday matters.

Is this how husband and wife usually relate to each other in Massys' day: she taking care of religious and spiritual matters, while he is occupied with secular affairs? Scarcely. And yet the picture does exemplify a moral debate that started in about 1500 and was to become a key discussion point with the economic upturn of the Netherlands in the seventeenth century. Calvinism and humanism condemn the uninhibited embrace of money as degrading idolatry, pure lust for profit as entirely despicable. Erasmus of Rotterdam, whose writings were a powerful influence on Massys' work, argues that a truly upright and virtuous life must first come to terms with the lure of money. In this he runs counter to other moral designs of the period, which see withdrawal to a monastery as the only alternative to earthly materialism. Against this background, Massys' moneychanger couple can be seen as representing the two poles of profit and contemplation. If these are kept in balance, a virtuous life is possible despite the temp-tations offered by money. The message is further re-inforced by the scene in the mirror and in the street. Through the window, reflected in the mirror, we can see a young man in a hat talking to an old man. In the context of its day, this conversation stands for hollow, gossipy, idle life. But in the mirror we see a man in a turban with a book in his hand, reading. So the two poles are repeated. And by showing a man engaged in contemplative activity in the mirror, Massys escapes he suspicion of having reserved spirituality for wives only.

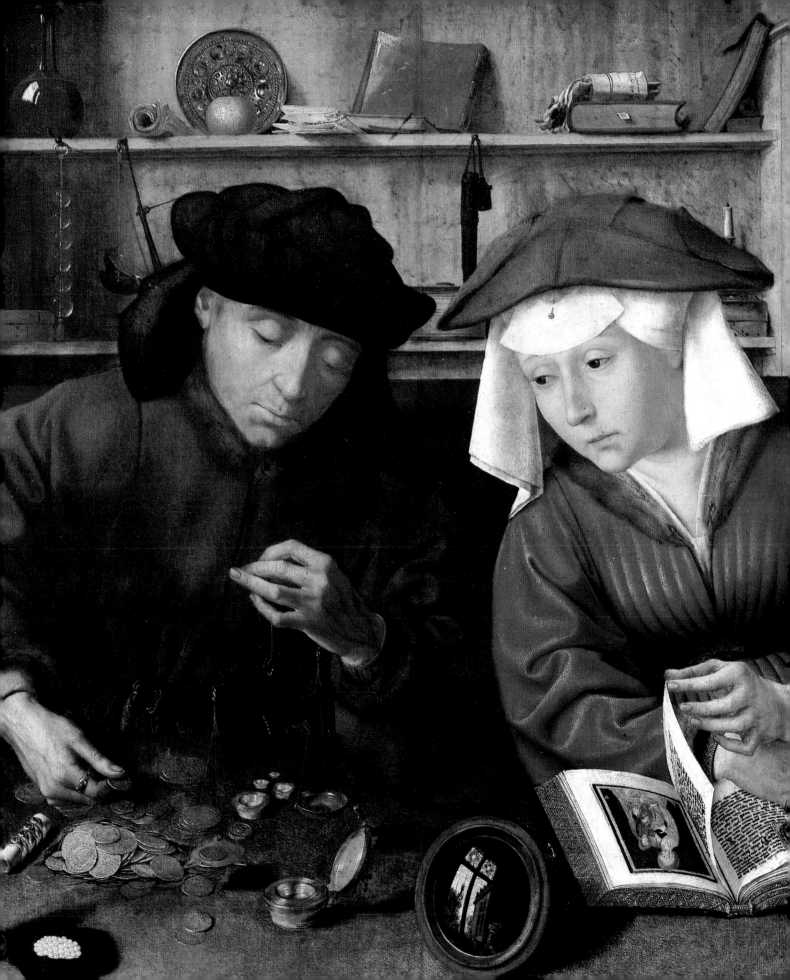

Bacchus and Ariadne

What's the matter with all you besuited, distinguished gentlemen in Business Class and other such privileged places – whatever happened to the passions of antiquity? Nobody has captured male desire as timelessly and divinely as Titian in his *Bacchus and Ariadne*. The young god is leaping from his triumphal carriage, exuding pure energy, almost soaring towards his Ariadne, the epitome of devotion and intensity. Not even a hundred red roses could compete with this show of emotion. It is a feast of love at first sight, and Titian is pulling out all the stops to celebrate it. The picture space is alive with sensual allusions. A Maenad playing a tambourine casts a longing glance at her drunken satyr, who is brandishing some animal's leg. Another Maenad is clashing her cymbals, and her breasts are already half exposed. Laocoön, wrestling with snakes, symbolizes male muscle-power and vitality. A small satyr wearing a garland of flowers is looking challengingly at the viewer, inviting him or her to join in this riotous celebration of love and marriage. Wine is being brought in at the back right-hand side of the picture. Silenus, Bacchus' foster-father, is already very much the worse for wear, which is why he has been put on an ass. Ariadne, who had set out for a desperately lonely walk around Naxos because Theseus had abandoned her there, seems absolutely stunned, and is turning impulsively away from Bacchus and his retinue. Titian shows her torn between attraction and repulsion. But the details of the composition anticipate her acquiescence. The red of her stole and the folds in her blue garment are in complete harmony with Bacchus' fluttering cloak. The expressions on the faces of the two leopards who are pulling the carriage suggest the couple's imminent intimacy.

The Duke of Ferrara, Alfonso I d'Este, chose the subject of Bacchus and Ariadne for the alabaster room in his country retreat himself, commissioning it first from Raphael, and then, after Raphael's death, from Titian. Ovid's *Fasti* and *Metamorphoses* presumably provided the literary model. This picture has such radiant luminosity and sparkling colouring, such dynamic figure design and vital gestures that it has a similarly powerful impact on the viewer as Bacchus has on Ariadne. Titian thrillingly invokes the power of passion, the return of love to the disappointed Ariadne's life. She had helped her beloved Theseus to find his way out of the Minotaur's labyrinth with a sword and a reel of thread. He promised to marry her and to take her to Athens, but then abandoned her on Naxos, where she was rescued and delivered by Bacchus.

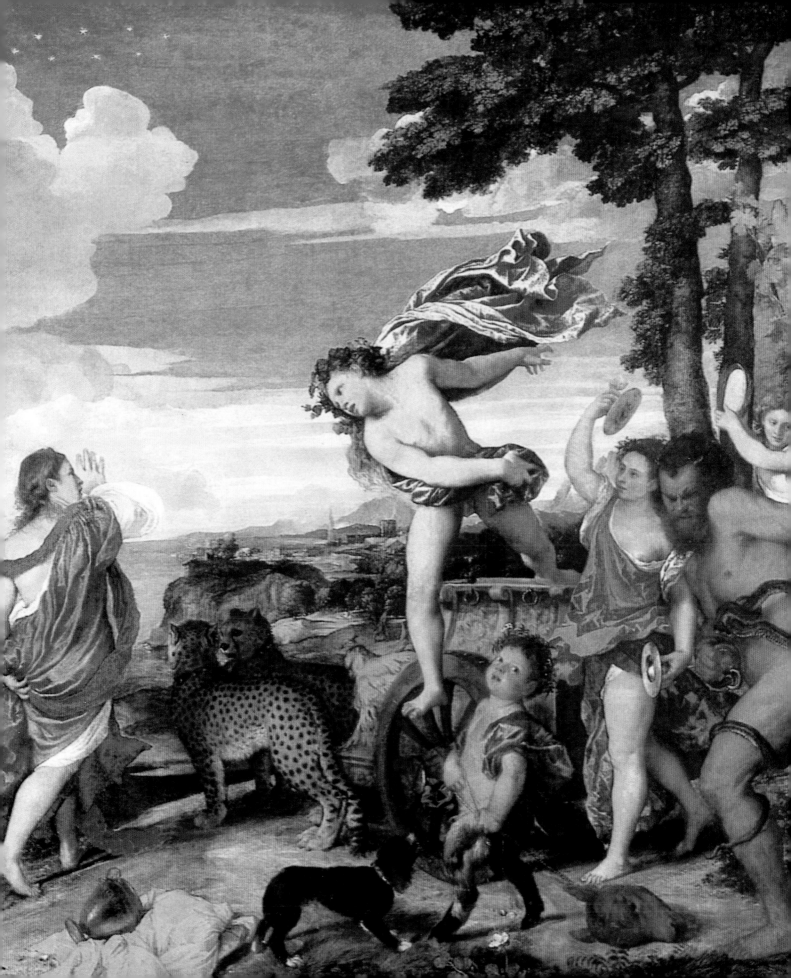

LORENZO LOTTO

Wedding Portrait of Marsilio and his Bride

Soft and dreamy eyes, serious and wise at the same time. These two young people seem to have a clear sense of what they are taking on. Lorenzo Lotto's wedding portrait is unusual in a number of ways. It was commissioned by the wealthy patrician Cassotti family from Bergamo on the occasion of Marsilio Cassotti's wedding, and it is a rare example of an Italian Renaissance double wedding portrait. Presumably Lotto was inspired by the Northern pictorial tradition.

The figures are portrayed in a way that reflects the prevailing ideas about marriage fairly precisely. It is not a life shared by equals that is being sealed by the handing over of the ring, but a joint existence dominated by the man. Lotto places Marsilio, dressed in elegant black, on a compositional vertical, while the movement of his wife's head not only inclines her towards him, it also makes her smaller and thus subordinated by the gesture.

He will continue to be active in public life, while she looks forward to the life of a housewife and mother. The young woman is obviously aware of this less than exciting, probably even boring, future. In any case, Lotto puts all his skill as a portrait artist into fine psychological analysis of the gestures and expressions, oscillating between serenity, boredom and dreaminess. But the most extraordinary feature of this wedding picture is Cupid, who is laughing mischievously, even maliciously. He is placing the matrimonial yoke on the couple's shoulders, binding them securely to each other. Cupid's love-arrows remain in his quiver, but the god has something else in his hand: laurel, to express virtue and love beyond death. The ambivalence of the ancient symbols (which Lotto presumably took over from his reading of humanist literature), promising eternal love on the one hand and subjugation on the other, gives the picture a dimension that goes well beyond a mere record of the wedding for the family archives. Lotto is bearing the couple's everyday life after the wedding in mind as well and is commenting on the sentimental lustre of the scene, which was something that he, as someone who never really settled down and always remained alone, was probably not really able to believe in personally.

In fact, Lotto is entirely in fashion with his essentially muted assessment of the blessings of marriage. A large number of moral and theological publications appeared in Europe in about 1530. These idealized marriage and gave all kinds of advice about living together well and in a way that would be pleasing to God. Literature and art took this as a reason to present a counter-argument with some rather more pessimistic assessments. But in Italy this tended to be the exception, which is why Lotto's wedding portrait occupies a special place.

PARIS BORDONE
The Couple

This woman has made a good match. She is young, blond, pretty, self-confident and knows how to make the best of herself. The handling of light, use of colour and the sophisticated folds and pleats in her elaborate dress make her the glowing centre of the picture. The fact that two men are present seems to make her all the more attractive and precious. It is not clear who the young man in the background is. A relative, a witness to the marriage, a former lover? Titian's pupil Bordone has chosen a strikingly unusual moment at which to portray this couple. The man is not giving the woman a ring, but a valuable item of gold jewellery. Her fingers are reaching out for this costly gift, moving precisely and greedily. In comparison, her lover's embrace seems rather reticent, and not really appropriate to a romantic relationship. His fingertips are scarcely touching her naked, ivory-coloured shoulder, and his expression suggests serene acceptance of the ways of the world, rather than enchantment. The gold is placed so conspicuously in the picture that we feel Bordone might be depicting a Venetian courtesan and her lover. Relationships between the nobility, rich merchants or craftsmen and beautiful women who were paid for their services were quite customary in Venice in Bordone's day, and accepted as such.

Venice, as a maritime power with the oldest prostitution laws in Italy, had a less restrictive policy about such matters than other cities, like Genoa, Florence or Bologna. A census conducted in 1526 recorded 4,900 prostitutes in a population of about 55,000. They were entitled to special protection, and were allowed to ply their trade with the Serenissima's approval in the red light district around the Rialto. There was even a hostel for ageing prostitutes, run under the auspices of the Doge.

In about 1500, or about the time this picture was painted, Venice developed a special form of prostitution featuring courtesans. The *meretrix honesta*, the honourable whore, was highly educated and in a position to satisfy her clients' refined cultural, musical and social needs. Her status often shifted smoothly to that of a mistress. Members of the nobility and patrician families in particular allowed themselves the luxury of keeping a courtesan as well as a wife. Given the Renaissance's obsession with antiquity, the *meretrix honesta* was celebrated as a successor to the Greek hetaera, and enjoyed correspondingly high social status. For the first time in history, women were able to establish an independent existence. Many became rich or were married by their lovers, though this was seen as scandalous in noble circles. It seems reasonable to assume that a rich Venetian might commission a portrait of himself and his mistress; she is an emblem of his wealth and status, like the gold jewellery.

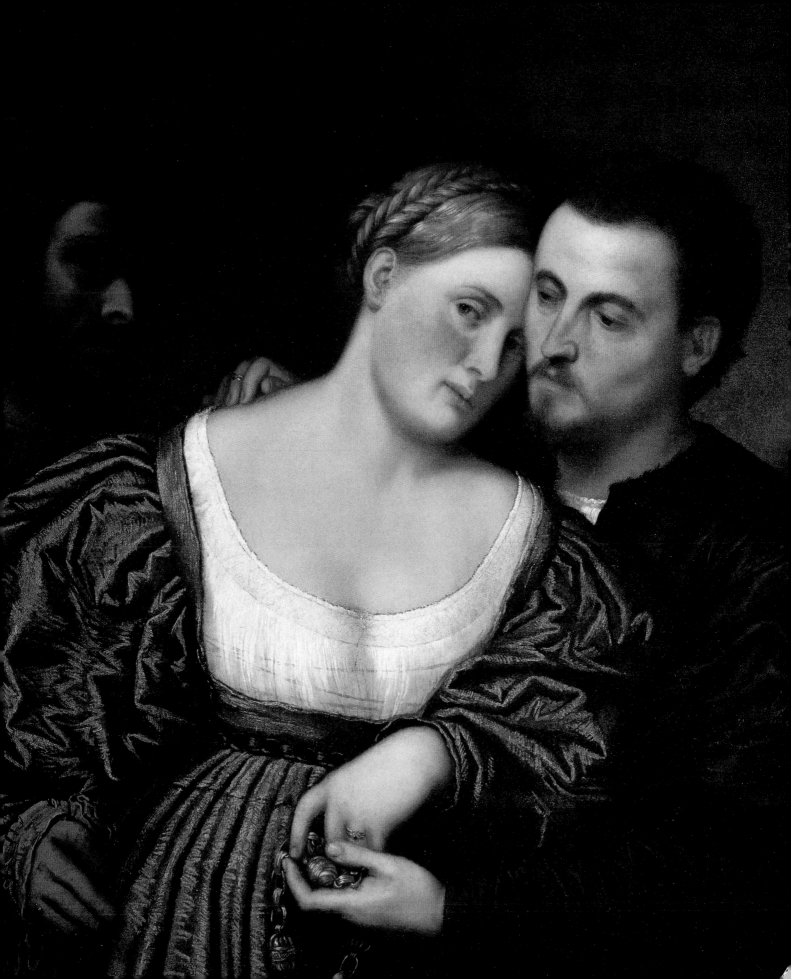

The Wedding at Cana

The plates are charged with exquisite food. The company is eating, laughing, talking, making music and taking time to pause – until the next course of this festive menu is served. A small dog is running around, a dwarf with a parrot and jesters with bells on their caps are entertaining the guests. The chief cook and his assistant are behind the balustrade, taking down orders. The cream of Venetian society has gathered here, as evidenced by the colourful, costly silks, elaborate ornaments, shimmering effects and decorative details such as trimmings, buckles, chains, belts or imaginative Byzantine headgear. Paolo Veronese, the great story-teller, pulls out all his painterly stops to capture the sensuality and *joie de vivre* of the feast.

This oil painting – almost ten metres wide and 6.5 metres high – is overwhelming in its size alone. Over 100 people are sensitively portrayed and arranged in groups with considerable compositional refinement. The bridal couple are not at the centre of the table. This place is taken by Jesus and Mary, but they are almost submerged in the opulence and bustle of events. The bride and bridegroom are seated well to the side of them at the left-hand end of the table, wearing the most valuable clothes and richest jewellery of all. It is difficult to believe that such hosts would run out of wine and that Jesus would have to help by turning water into wine, as the sacred aspect in this essentially profane setting is secondary. Even the butler seems more like a connoisseur with his silver-white, elaborately patterned robe, striking a gracious pose as he expertly assesses the colour and age of the wine. Veronese is using this painting to present a naturalistic image of a mid-sixteenth-century Venetian feast, which was exactly what his client wanted him to do. Veronese painted the picture for the refectory of the Benedictine monastery of San Giorgio Maggiore, at that time the wealthiest monastery in Venice. Subsequently, the Servites and the Dominicans also commissioned such paintings from him, which finally led to his summons before the Inquisition. Depictions of sensuality and seductive delights had been forbidden since the Council of Trent in 1563. Veronese had to explain why a picture that was commissioned as a Last Supper, showed dwarves, drunken German soldiery and a man with a nosebleed – with the saints and apostles thrown in. He was required to paint over the offending elements. Instead, he simply changed the title of the picture to *The Feast in the House of Levi*. According to the Bible story, Levi was a non-believing, rich tax-collector who later converted. Veronese confidently put it to the inquisitors that the picture showed Levi's extravagant lifestyle before he saw the light.

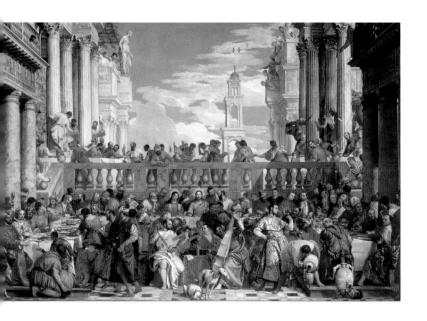

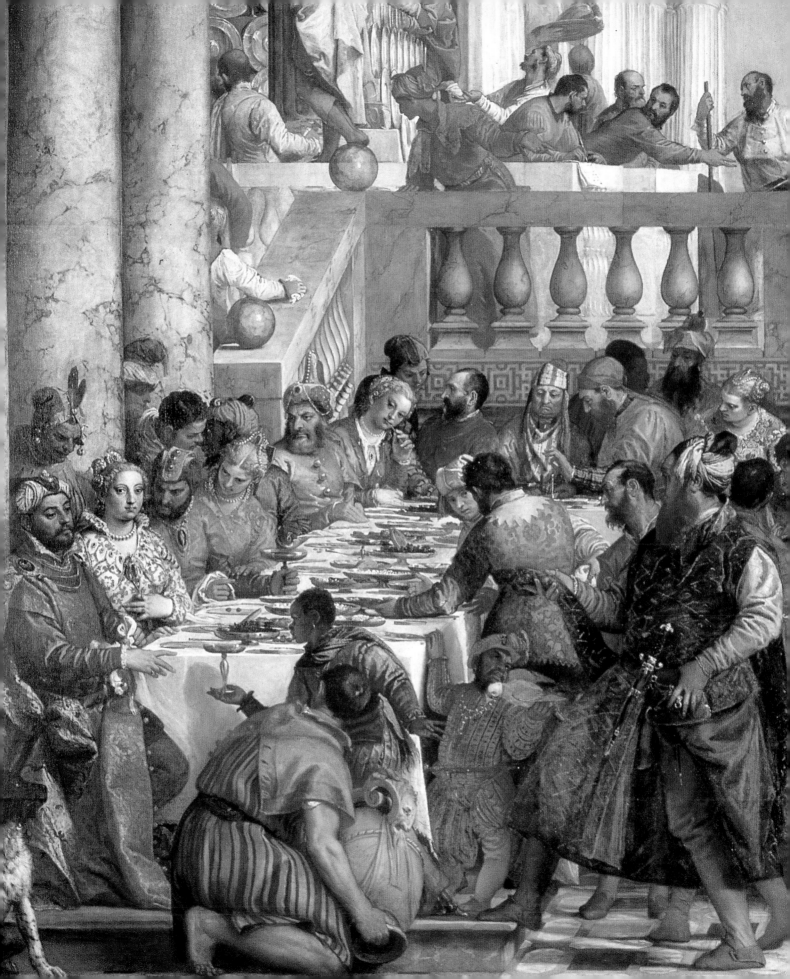

The Peasant's Wedding

The heights of sensual joy and glorious exuberance! It is a wedding day. Today, the everyday world can be forgotten, and the festive mood is rising to a climax. Pieter Bruegel the Elder captured this moment with charming realism and enormous attention to detail, allowing the viewer to come in through the door and stand in the middle of the festivities, with a diagonal perspective. A long table in a barn and the meticulously portrayed guests are packed tightly around the table with its white cloth. The women are wearing brightly coloured clothes and white festive bonnets, the men are dressed in fine fabrics. The spoons rattle, lips smack and chatter, cheeks are glowing and eyes looking greedily down at plates, jugs and tankards. A child in the foreground is bent on licking out the dishes with its fingers. The man in charge of the drinks is keeping up well with serving the beer, the cooks are constantly carrying in

new supplies. They have their work cut out to fill the hungry mouths. The venerable gentleman in the armchair is the notary who drew up the marriage contract.

Although the bride is at the centre of the scene, she is a somewhat lonely figure sitting there, eating and not saying anything, as tradition requires, looking down at the ground, her hands folded demurely. But Bruegel has given her the broadest and most contented smile of anyone at the table. She seems to be pleased with the feast and her new husband. Her hair falls loosely around her full cheeks, she has a small garland on her head and behind her is the bridal crown in front of a blue hanging. But: where is the bridegroom? Some interpreters think he is the man serving the drinks. Folklore knows better: the wedding feast traditionally took place without him.

We are in Flanders in the early seventeenth century. The peasants' work in the fields is a life of privation, each harvest is a triumph of the will over the vagaries of nature. Fairs or weddings are the only pleasures and distractions. They keep families and the village community together, although they often lead to excesses and end up in drinking bouts and fights. A number of brides' fathers went bankrupt after their daughters' weddings and had to start all over again. This is why Charles v issued a decree to ban such dissipation. The edict limited the number of guests at the wedding feast to twenty, and the celebrations were not to last for longer than one day.

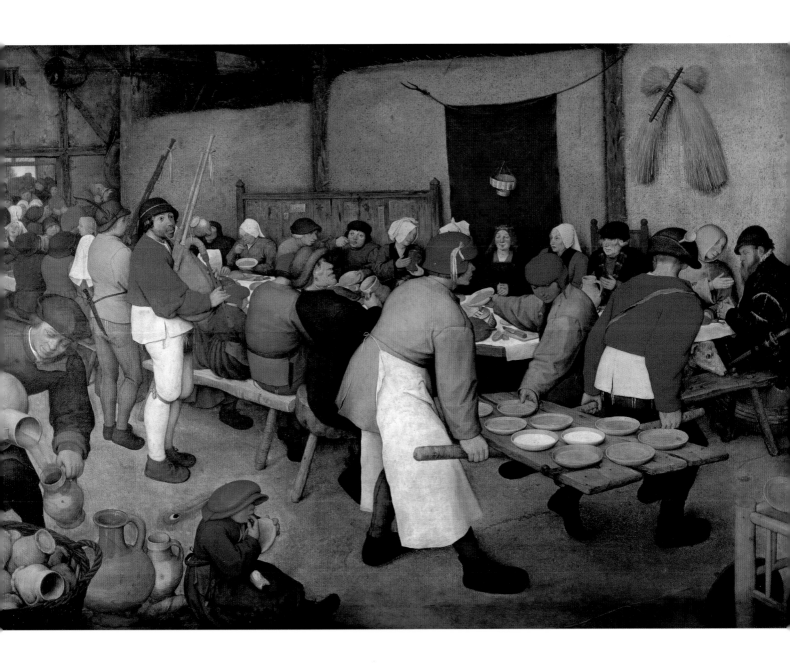

PETER PAUL RUBENS

Rubens and Isabella Brant in the Honeysuckle Arbour

Costly fabrics, lace, gold thread, exquisitely cut clothing: this couple would probably wear Gucci, Chanel or Yves Saint Laurent today. In any case, they are very well off. It is not clear at first glance what the man does professionally. He is perhaps an important dignitary or a rich merchant. But a painter? Here Peter Paul Rubens appears in his own wedding portrait with his first wife, Isabella, the daughter of a prosperous and respected Antwerp patrician. Rubens is dressed as a private individual and well-to-do citizen. But there is nothing stiff or conventional about this full-length portrait. The two people are sitting leaning towards each other in the open air, relaxed, carefree and cheerfully composed. Their right hands are touching, tenderly and naturally, his left hand is resting casually against her hat, the hem of her skirt has covered his foot. Rubens shares with his viewers the fervent look they would

usually save for each other, thus making them into witnesses of a very intimate and private moment. This is a love-match, there is no doubt about that. And although the young woman is sitting a little lower in the shade of the foliage, and the man slightly raised, and facing out to the world a little more, Rubens' composition leaves no doubt about their equal standing. Both are framed in an oval and set within a luxuriantly blooming honeysuckle bush. Honeysuckle is also a symbol of eternal love and fidelity. For example, a thirteenth-century work on Tristan and Isolde by Marie de France says:

> For without her he could not live.
> The two of them fared so
> As did the honeysuckle
> that twined around a hazel branch:
> they live right well together
> but if they ever parted
> the hazel branch would die forthwith
> and the honeysuckle with it.

By choosing the arbour, Rubens is also reviving the medieval tradition of presenting lovers in a *hortus conclusus*, an enclosed garden.

Unfortunately, the couple's happiness was short-lived. Isabella died young and Rubens survived her – in contrast with the Tristan poem – for a number of years. As a convinced family man with strong Christian beliefs he found a new love and remarried several years after Isabella's death.

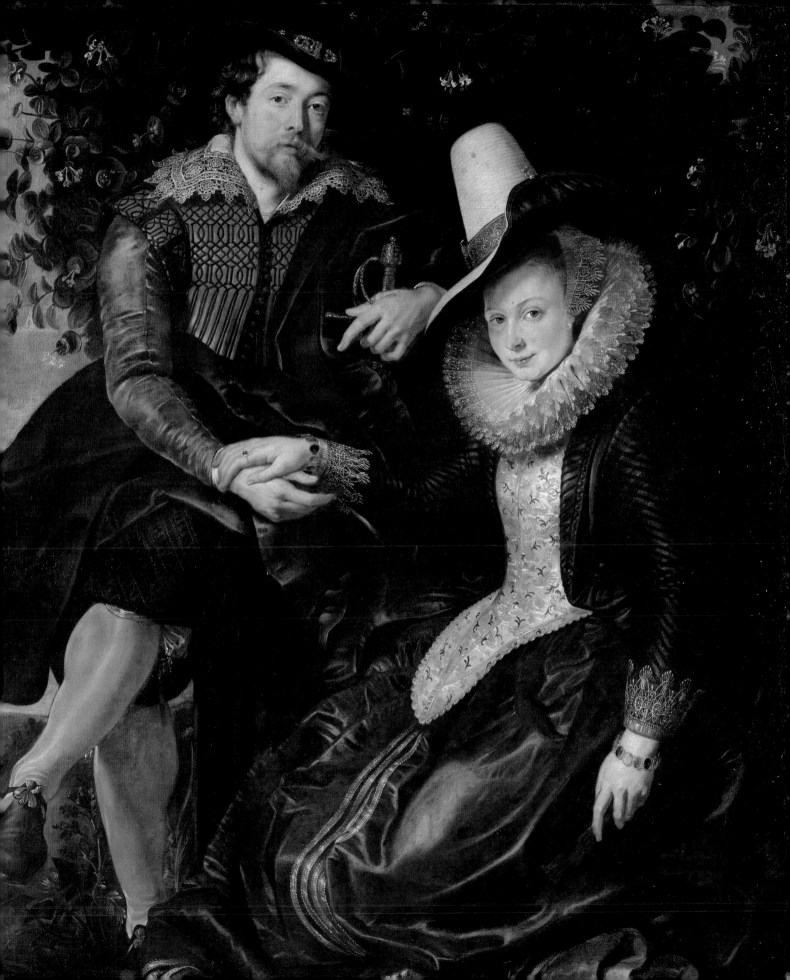

FRANS HALS

Lucas de Clercq and Feyntje van Steenkiste

Marriage as a monastic struggle for chastity – this could be a somewhat off-putting motivation for lifetime commitment from today's point of view. These two portraits are sensitively executed and observed. They show us and provide a model record for posterity of a life that is quite definitely lived out in a way that is pleasing to God. The pictures' subtle message is that it is only by overcoming worldly desires that the partners have been freed from earthly constraints and led to higher, true pleasures. Frans Hals gives the wife particularly monastic qualities. Her hair is pulled back severely and hidden under a plain bonnet, the lines of her body are concealed by swathes of black material. Her hands are clasped demurely and devoutly. The only sensual touch that the painter allows the wife is that these hands are bare, and not inside the precisely draped white gloves. The husband is also dressed in reticent black, but he is a bigger presence, and also more worldly and dominant than she is, with his hand on his hip. The two of them represent classical patriarchal marriage. In seventeenth-century Dutch society the husband was seen as the king of the family, and the wife at least took part in his household rule. "Men have to earn money and make sure that the family wants for nothing; women have to watch over spending, and save," says a contemporary writer. And there were clear guidelines as far as other marital duties were concerned: "The marriage bed should not serve base desires."

This pendant portrait, which seems to meet these social requirements perfectly, was commissioned by the merchant and lawyer Lucas de Clercq and his wife Feyntje von Steenkiste. They came from two of the most influential Haarlem families, and their marriage meant securing their standard of living, increasing their capital and enhancing their social power and influence. Both were Mennonites, subscribing to a Calvinistic persuasion that rejected jewellery, fashionable clothing and outward shows of luxury. Modesty and self-imposed moderation were the ideals of a life placed entirely at the service of God.

The couple had been married for nine years when these two pictures were painted. They are mirror images of each other, and were intended for the couple's descendants from the outset. They were willed to them immediately after completion, and thus have ancestral and documentary qualities.

The striking feature in comparison with other portraits of married couples painted by Hals at this time is the ascetic approach. No elaborate lace cuffs, no gold fillets, pearls, bracelets or rings to draw attention away from the couple. This means that the faces make even more impact; the painter captures the finest nuances with great virtuosity.

Hals compensates for the lack of decorative pictorial elements with masterly attention to detail. The play of light on the clothes and the dynamics of the brushwork in accessories like gloves, which make a delightful contrast with the otherwise deliberately restrained strokes, give the pictures a sense of excitement and a strong, dignified aura.

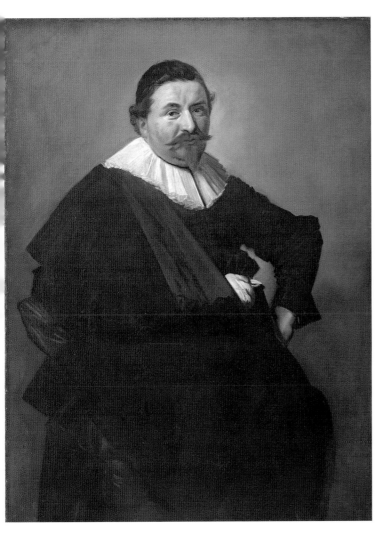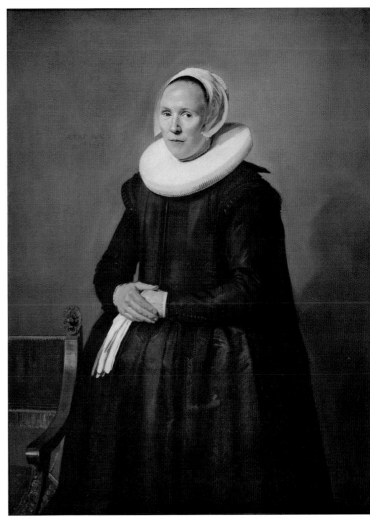

Rembrandt and Saskia

Here are two people having a very good time. Beer, women and song – what more could a man of the world ask for? His mouth is open in an exuberant laugh, his cheeks are red, his head already slightly befuddled with alcohol, his hand in close contact with the beautiful girl's waist. Every brushstroke speaks of a life lived to the full. The clothing on the lower part of the woman's back glows provocatively at the viewer. The man of the world, awash with sensual delight, is rocking the object of his desire to and fro on his left knee. The table is lavishly laid, roast chicken and peacock pie are waiting to launch the erotic adventure. The evening is approaching its climax, the food is as yet untouched. And the girl? She does not seem entirely averse to his advances. She is looking over her shoulder at the viewer in some surprise, her eyes velvety with bedroom happiness. But her pose is upright, even slightly awkward; this

creates a tension between her and the man's relaxed body, which is leaning backwards.

Even though the Dutch in particular were pioneers of a friendly, loving approach to marriage in the seventeenth century, starting the transition from patriarchal to comradely marriage – what is shown here breaks out of this framework. It expresses something that would have been seen as vulgar sensuality in terms of the taste and moral ideas of the day. There is a great deal to suggest that the scene is set in a brothel. And even from today's point of view this double portrait suggests an amorous adventure rather than marriage.

It is therefore all the more surprising that the two people in the portrait are Rembrandt and his wife, Saskia Uylenburgh. And more surprising still that the picture was painted shortly after their wedding in 1634. Saskia was the wealthy daughter of a mayor of the town. This marriage enhanced Rembrandt's social status considerably. Rembrandt always had a liking for eccentric themes, and here he stands the classical marital portrait completely on its head. It is the only portrait of the two of them.

On the other hand, this painting is not an autobiographical document, but depicts a Biblical scene: the Prodigal Son, who squanders his inheritance from his father, then later repents and returns home, asking his father to take him on as a day-labourer (Luke 15, 11–32). It was perfectly usual in Rembrandt's day for family members to sit as models, and for the painter himself to appear as someone like Nicodemus or Joseph of Arimathea. Scholars are inclined to the view that the young woman's tense pose in the painting suggests that Saskia was not entirely happy for her husband to portray her as a woman of easy virtue.

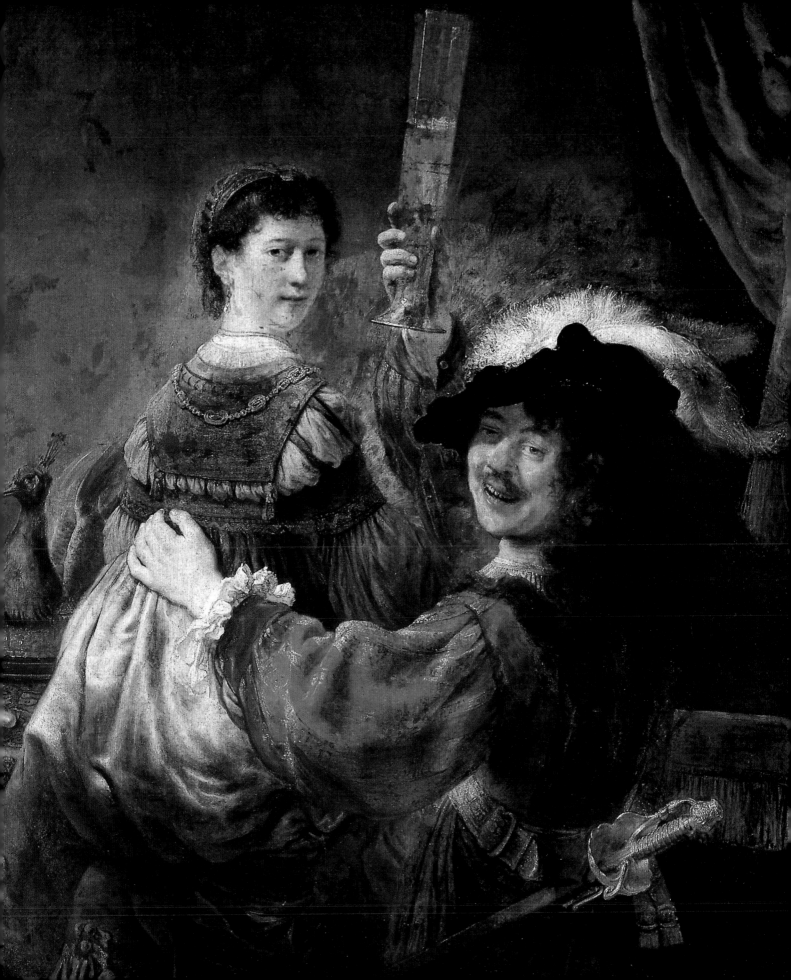

VERMEER

The Glass of Wine

There can be no sensual delight without a prelude. It is not difficult to guess the man's intentions towards the woman. He is looking down at the object of his desire contentedly, indeed almost contemptuously. He has his hand firmly on the pitcher, ready to refill the glass as soon as the woman has emptied it and put it down on the table, which is covered with a costly oriental rug. Perhaps he has previously been playing his lute, to weaken her resistance with a lively rondo. However, it is more probable that he missed out this part of the prelude and went straight for the relaxing and aphrodisiac effect of alcohol. In comparison with other Vermeer paintings dealing with wine, women and song, the musical instrument and sheet music have been shifted towards the periphery of events.

The man we are seeing here is not a cheerful flirt. The sexual element has been pointed up quite unambiguously: the woman is not going to be coy any longer, she has already finished her wine and yielded to seduction. But the atmosphere is not at all relaxed, for there is a sense of uneasiness and tension. We almost feel sorry for this girl with her face hidden in shame behind the loving-cup. She has slipped forward on the chair. The table leg is in the way of her knees, which are parted underneath her dress. And the man is not even trying to make the situation any more comfortable for her.

He could easily slip his arm along the back of her chair, to give a hint of closeness. But the intimate gesture is stillborn under his cloak.

Women who have overindulged in wine are a recurrent motif in Dutch painting in general, and in Vermeer's work, as the embodiment of a depraved life. Morality relaxed with the economic upturn in the seventeenth century. The attractions of an amorous adventure were often too much for marital fidelity. Calvinists and humanists alike saw a virtuous society threatened by affluence, and preach moderation. Alcohol was linked directly with prostitution. The moralistic writings of the day insisted that women should be forbidden to drink altogether. Vermeer was aware of what was in the wind, and commented on it in his own way.

In *The Glass of Wine* the lover is not directly opposite the young woman; she is facing the half-open window. The pane is decorated with an image of Temperantia, moderation, as a reminder that the path of virtue should never be abandoned. 'Perfectus amor est nisi ad unum' – perfect, true love is for one person only – is the motto of an emblem dating from 1608, to which Vermeer is presumably alluding. The girl in the picture seems to be ignoring morality altogether – as a warning for other hotheads looking for love in a hurry …

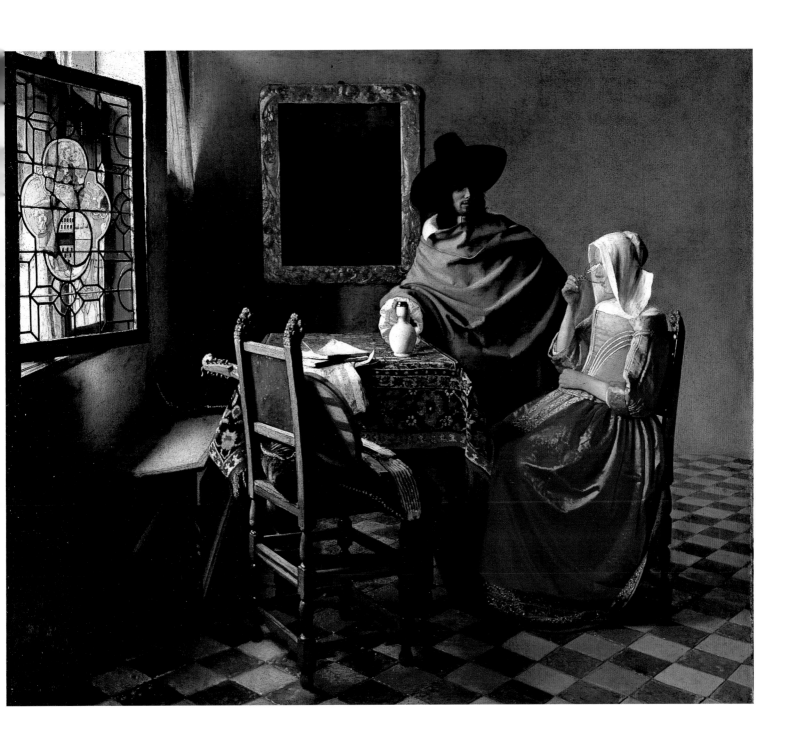

ANTOINE WATTEAU

Le Faux pas

How will this tender moment end? It would be jumping to conclusions to trust the title of the picture – it was not added until the nineteenth century. Is the young man really committing a faux pas with this warm embrace? Is he breaking the silken thread that has been so carefully spun between the two of them? Yes … or rather, no. It is one of the rules of the game of courtly love that the young lady should reject a young man who abandons gracious worship from afar for more tangible matters. Which does not, in fact, say anything at all about the female party's actual feelings vis-à-vis this more tactile approach. And it is just one of these moments of crackling erotic tension that Antoine Watteau, the great master of *fêtes galantes*, captures in this little picture. The nape of the alabaster neck that the blond beauty is revealing to the viewer – and not just to the viewer – really is charming. The young man's face is flushed with desire, and his breath is almost stirring the hair on her nape and making it tremble. Only a fraction of a second need elapse before she sinks back onto the soft grass, where a red cloak is ready for her to lie on. Nothing in the composition of the two figures seems awkward or lacking harmony. The woman's gesture of demur is poised somewhere between yes and no, elegantly joining the narrative dance of the other two hands. Watteau is a master of the ambivalent oscillation between eroticism and a sense of shame, thus capturing the magic of love, which is so difficult to explain. It is unusual for a couple to be shown alone and not in a group – the painting was cut out of a larger *fête galante* with a razor. In the late seventeenth and early eighteenth centuries, the French bourgeoisie and the aristocracy were practically addicted to pictures of courtly social games. Most of these took place in the open air, and were based on refined flirtation as well as witty conversation. Longing to be together, making a sophisticated play for someone's affection and fulfilment of the longing for love are recurrent motifs in Watteau's pastoral idylls. Spiritual yearning is more interesting than physical union. Sex is denied – or at least postponed, as in *Le Faux Pas*. The idea of courtly, intimate and spiritualized love came into fashion in the Paris salons in about 1650. Women wanted crudely sensual desire, which is also seen as brutal, to be transformed into reticent, tender love. Something that is over as soon as the couple decide to marry – at least as far as salon culture is concerned. Love and marriage are not compatible with each other, a realistic view still taken in Watteau's day. Embarkment for the Arcadian island of Cythera, the subject of one of Watteau's major works, is now seen as representing the marriage of reason and sensitive, imaginative love.

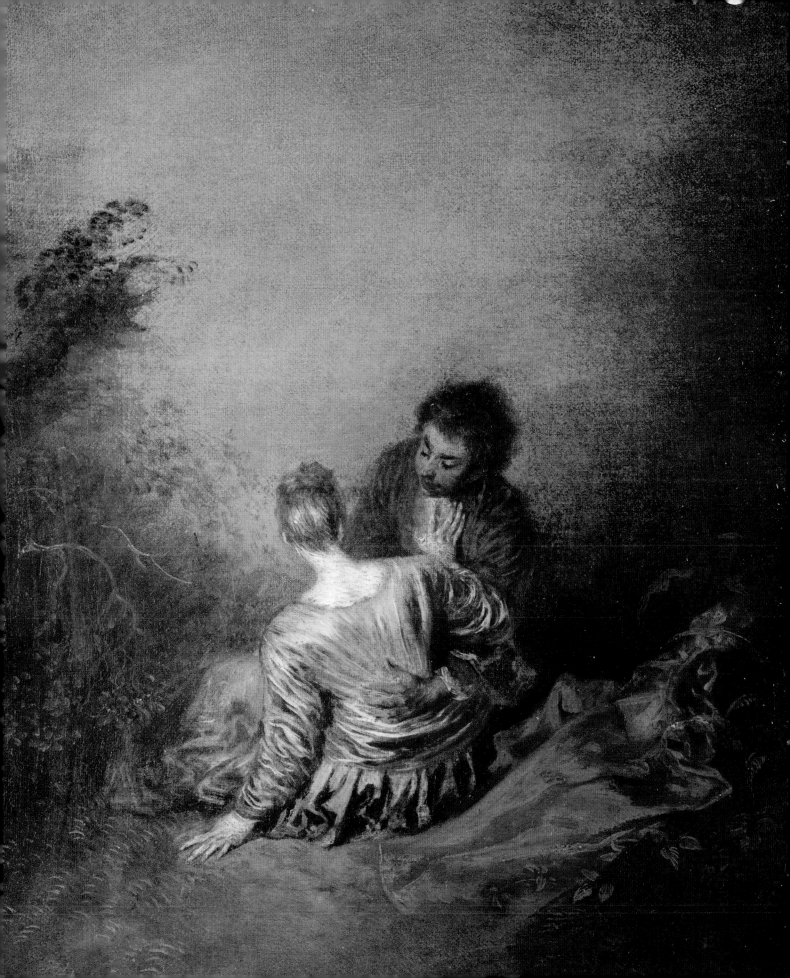

FRANÇOIS BOUCHER

Hercules and Omphale

Hollywood could not have staged it more movingly. Omphale, soft-skinned and tender, lies in Hercules' powerful arms. The rose-pink baldacchino and the drapes and covers on the velvet-red love-couch are as tangled as Hercules' and Omphale's emotions. We can feel the warmth of the sheets, his supple, muscular body, her silky, naked skin. Boucher puts all the painterly refinement he can muster into the delicacy of the surfaces and the colouring, driving the eroticism and magic of this passionate moment to the greatest possible heights.

The bedchamber, bordered by columns, exudes the sweet and sensual atmosphere of a boudoir. The two putti at the couple's feet are looking discreetly away from the almost completely naked lovers, which makes the scene even more intimate.

Hercules hand is caressing Omphale's full breast with sovereign confidence. He is a man of the world through and through, but remains completely relaxed, despite his burning passion. His feet, resting on a green velvet roll, are crossed casually, while Omphale's left leg is laid coquettishly across his thighs.

The mighty queen regent of the kingdom of Lydia is caught a little off her guard here. She seems all too willing to submit to the amorous wiles of the strong, handsome Hercules. This is a remarkable portrayal: Boucher's approach runs counter to most literary sources, and breaks away from the usual pictorial tradition, which follows this version of the story: Omphale buys Hercules as a slave in the market-place, and he is obliged to perform household duties for her, a myth that anticipates modern day-to-day role reversal – the woman takes over

the man's work and vice versa. Omphale makes the mighty Hercules into a house-husband, thrusting distaff and spindle into his hand. She takes over the insignia of his manhood for herself – the lion's skin and the club of wild olive-wood. They swap clothes in a grotto, as part of their love-play. Hercules wears Omphale's silken garment and her jewelled bracelet. She wraps herself up in his lion-skin.

Pan has fallen in love with Omphale and intends to seduce her in the grotto at night. The change of clothes puts him in an embarrassing situation. His caress under the silken garment finds Hercules' body rather than hers, and Pan is scorned and mocked. But what does Boucher make of this material? Other artists show Omphale sitting on a throne, with Hercules at her feet holding a distaff and wearing a jewelled bracelet, or at least the couple's attributes are changed over, but Boucher re-establishes the traditional gender identities. The two putti are in charge of the distaff and the lion's skin, but the colour scheme makes it quite clear how things relate to each other. The blue-green wings of the distaff putto correspond with the blue ribbon in Omphale's hair and with the light blue-green of the sheet she is sitting on. The lion-skin putto's red ribbon takes up the red of the bed Hercules is sitting on. And the jewels are on her arm, not his. Boucher's version of the material creates an image that was almost scandalously erotic for its day, thus reinforcing the traditional gender roles. Or might he have had a presentiment of the strong, emancipated woman, longing for a stronger man?

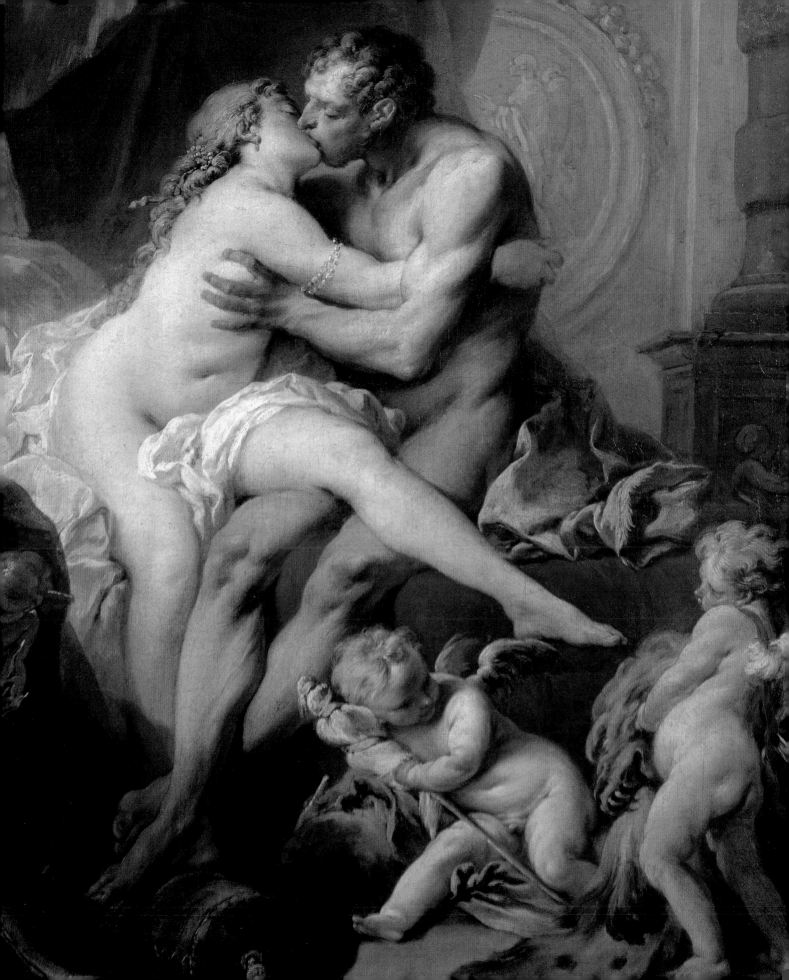

THOMAS GAINSBOROUGH

Mr. and Mrs. Andrews

Spring is now long past – for this couple as well, the landowner Robert Andrews and his wife. High summer is holding sway, the crops are being harvested, the heat has dried out the trees and meadows. The young, red-headed woman on the bench also too, seems somewhat brittle and unkissed. Just as nature awaits the approaching thunderstorm and the relief its rain will bring, she seems to be thirsty. Her pose is stiff and correct, her lips pressed tightly and tensely together. There is already a sense of bitterness playing about her mouth, and this could affect her whole face in a few years' time. Her billowing, sky-blue dress is so wide at the hips that it keeps everything at a distance. Not a single fold of material links the puritanical Mrs. Andrews with her husband. Gainsborough even leaves a tiny gap at the point where the two are almost in contact, between the left sleeve of his elegant beige-grey hunting coat and her dress. This marriage does not seem richly blessed with passion and sensuality. Mrs. Andrews' feet,

in her delicate pink shoes, are decorously, almost defensively crossed, and find their formal counterpart in the entwined feet of the park bench. It is difficult to imagine this married couple as lovers, though the relationship may function perfectly well on a day-to-day basis. The fields are luxuriantly fertile and the estate seems well cared for. The Andrews' affairs are in good order, a certain pride in what they have achieved together emanates from the otherwise impenetrable faces. This is an occasion for good form and correct behaviour; private feelings would be out of place.

Mr. Andrews has just come back from hunting and master and dog seem closer than man and wife. Though relations between the couple are not all they might be, and possibly their union has not been blessed with children, the couple fits harmoniously into the landscape. Nature and the people involved are perfectly balanced in terms of composition. Gainsborough was passionate about landscape work, but not so fond of painting portraits, even though he earned his living from them. He puts the natural scene tended by the land-owning couple firmly at the centre of the picture, and shifts the people into the left-hand section; the picture would certainly lose its charm without the meadows, fields and trees, and the moving sky. The colours of the clothes fit in with the landscape backdrop. The beige-grey of the hunting coat is picked up in the clouds, the bright blue of the dress in the sky, the yellow of Mrs. Andrews' hat and underskirt in the meadows and the ears of corn. Working together on the estate makes their everyday married life easier, pushing private difficulties into the background. Things would certainly not have looked different if Mr. and Mrs. Andrews had been painted in a salon atmosphere.

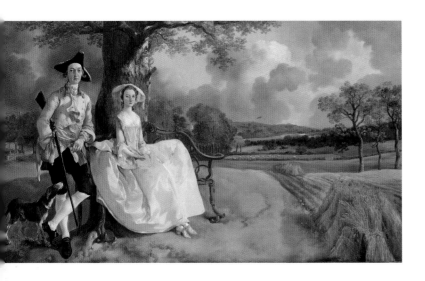

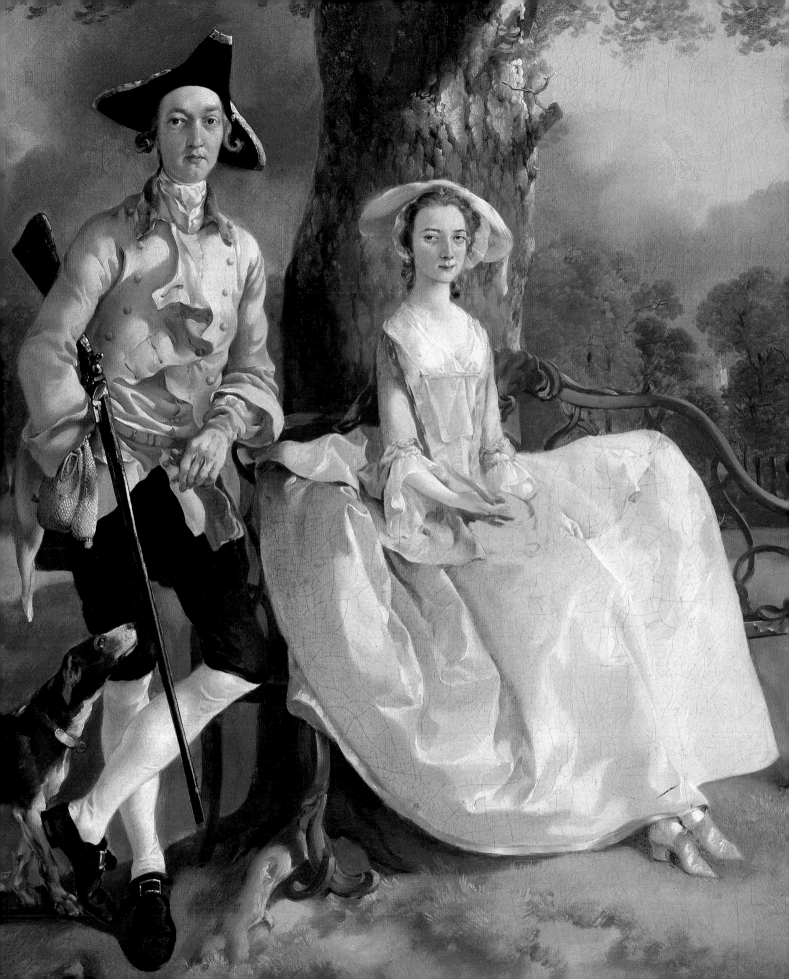

The Stolen Kiss

An alarming moment, as sweet and delicate as a candied rose-petal. The young woman has left the salon, her friends are enjoying themselves at their game of cards. An airy, transparent stole she must have left behind was lying on a sewing-table in the anteroom. Its white satin stripes vie with the mother-of-pearl sheen on her billowing silk dress. Is it by chance or is it planned that at precisely this moment a young man comes out of a side room, tenderly reaches out for her wrist and breathes a kiss onto her cheek? She is obviously surprised by this erotic approach. Her right hand is conveying a warning, but the gesture suggests fear of discovery rather than disinclination. The painter uses a skilful compositional trick to show that the young lady is, in fact, by no means averse to this amorous ambush: this icing-sugar beauty is not merely the shining centre of the scene. Her head, left hand and stole lie on a diagonal that lends an extremely lively dynamic to the events: this rococo lady is practically sinking towards her admirer. Opportunity makes for love every time in the days just before the French Revolution. This is decadent nobility is amusing itself as it moves towards its last climax. Life is nothing but light comedy for court society. Lovers' trysts and intimate rendezvous become part of life, and frivolity is made a virtue. Pleasure is the priority, and it is seeking ever more refined and audacious sensual delights, ever more obscure and delicate pleasures. Since the Enlightenment had demystified the myth of love and defined sexuality as a biological impulse, fidelity and financial security were becoming increasingly less important as bases for marriage. Mutual responsibility and commitment between man and wife were sacrificed in the flowery meadow of erotic piquancy and stimulating flirtations. Sex with casual acquaintances is free and easy and taken completely for granted, women wear nothing under their silk dresses. The drawback to all this dissolute behaviour was more and more illegitimate children, who were sent to foundling homes or left to grow up on their own, completely neglected by their parents. There was no room for suffering, old age, frailty, sin and loneliness among all the fun of rococo society, over which the guillotine blade was already poised. But before it falls, Fragonard once more calls up tender dalliance in its prettiest pastel facets. He captures the most coquettish and gallant forms of young love on canvas with effortless ease. Here, he skilfully selects the most erotically stimulating, fleeting moment between surprise, rejection and devotion, and captures it for a brief moment of eternity.

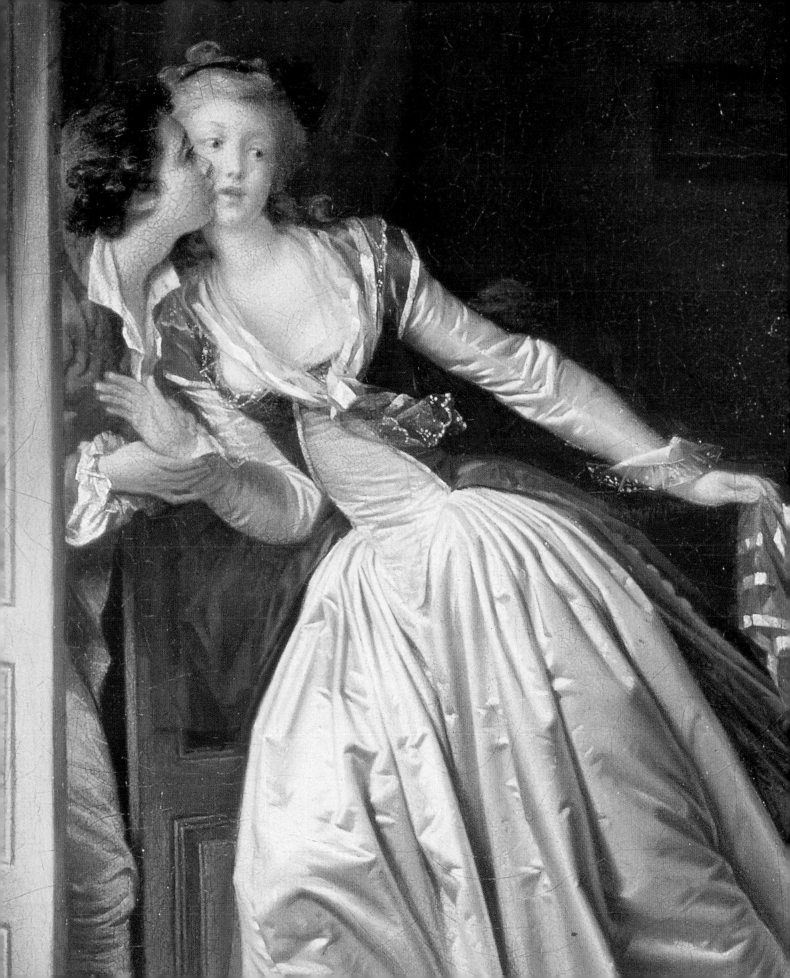

FRANÇOIS GÉRARD

Cupid and Psyche

Who are you? The Roman writer Apuleius gave a name and a shape to the primeval feminine longing for complete and perfect exploration of the beloved, right down into the depths of his soul, in the figure of Psyche. The myth of the king's beautiful daughter is the embodiment of one of the most popular themes in the modern literature of relationships: women's insatiable thirst for emotional knowledge and men's tendency to escapism in these matters. Simply being happy in love is not enough for Psyche. Her curiosity about her lover's most intimate secrets makes her gamble with divine love, and is punished with long loneliness and separation. Men nowadays tend to clam up when women pry into their innermost souls, or 'escape' by saying nothing.

But things are more complicated in the case of Psyche's partner, Cupid. The goddess Venus is envious of Psyche's beauty, because more and more men are turning away from her to worship the king's young daughter. Venus is embittered, and sends her son Cupid to Psyche so that he can make her fall in love with the ugliest creature on earth. But as soon as Cupid sees Psyche he falls in love with her himself, goes against his mother's wishes and instead seeks help from Apollo, who demands through an oracle that Psyche's father should place his daughter in a wedding dress on a lonely mountain peak, where she is to wait for her bridegroom. A gentle breeze wafts Psyche from there into a hidden valley. A voice leads her into a glittering golden palace. When night falls, Cupid lies down with her in human form. He tells her that they are to be man and wife, and that they will live in peace and happiness as long as she does not ask who he really is. Psyche is not able to resist the mystery for long. Egged on by her sisters, she holds a candle to her beautiful lover's face one night. The unmasked god makes his escape. Psyche searches for him in desperation, embarking on a long and arduous journey. She almost loses her life on a number of occasions, but she is finally captured and rescued by Cupid.

Gérard is a classical painter, and so he does not choose to paint the happy ending, but the moment when the two first fall in love and tentatively touch each other. Cupid and Psyche seem too good to be true. Their immaculate bodies are like alabaster, their eyes dreamy. Cupid's hint at an embrace is theatrical, and Gérard effectively holds it open and undecided. The secluded valley is strewn with flowers, and leafy trees, gentle hills and a butterfly above Psyche's Empire hairstyle give the scene the gentle lustre of spring. The wedding dress is a mere breath, playing around the body and covering up anything that erotic and sensual stimulation could have made banal. This is how beautiful divine love can be …

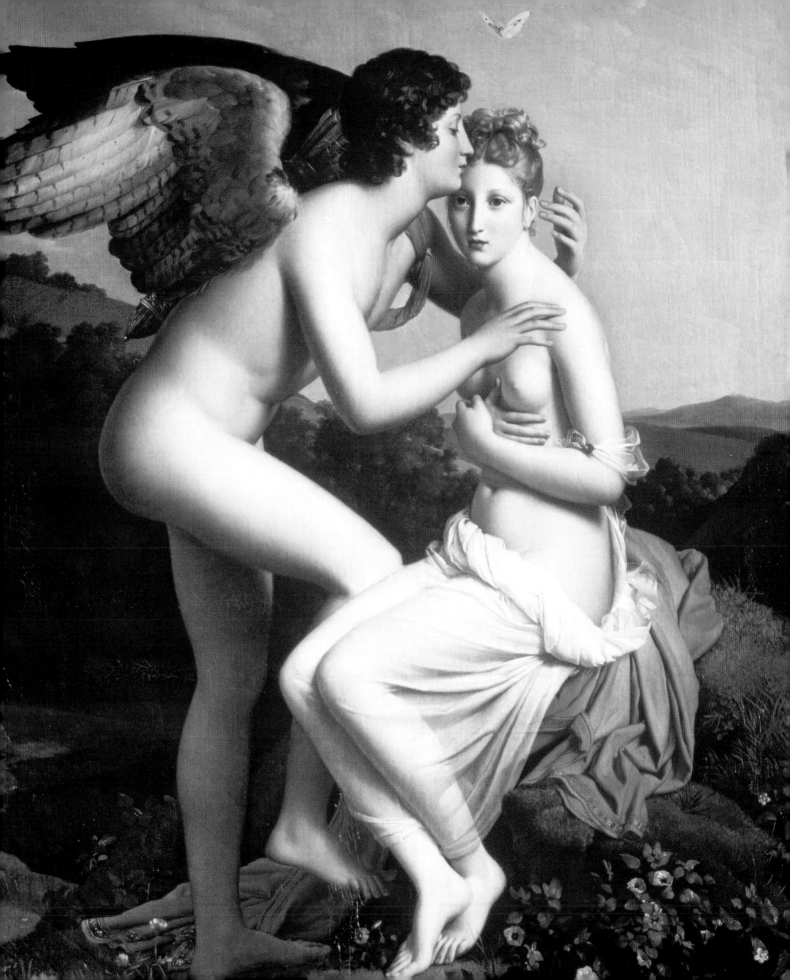

CASPAR DAVID FRIEDRICH

On the Sailing-Ship

Two people have left a safe harbour and are setting off on their travels together. The sailing-ship is carrying them into an uncertain future. They are looking out over the sea ahead, on the watch for new shores. A town with Gothic towers and buildings is looming promisingly on the misty horizon. The sea is calm, the sky lightly clouded, clearing the closer it is to the land. But will the two ever reach the coast? They are not the only people with a say in where the voyage will go. Who is steering the boat? Who is at the helm?

Mast and sail tower up, tall and powerful against the sky with its threads of gold. How small the couple is in contrast – and yet their deep affection seems to have armed them against the storms of an uncertain fate.

The two are sitting hand in hand at the bow of the sailing-ship, left entirely to their own resources. Their bodies are turned to each other in natural, unaffected poses. Nothing seems false, or dictated by social constraints. Their eyes may just have met, but they are now absorbed in the show of nature and the distant goal.

The profound sense of intimacy conveyed by Caspar David Friedrich's painting *On the Sailing-Ship* is meant to touch our hearts. It is a Romantic hymn to the relationship between two people who are deeply in love, facing the vagaries of nature with complete calm, utterly resigned to their fate. The picture is in shades of yellow, brown and green, and was painted shortly after Friedrich's honeymoon. To the surprise of his friends and family, the apparently confirmed bachelor had married Caroline Bommer, who, at the age of fourteen, was nineteen years younger than him, in 1818. A little later, the newly married couple travelled to visit the family in Greifswald, and them with Friedrich's brother Christian and his wife to Wolgast, Stralsund, Rügen island and

other places on the Baltic coast. Friedrich distilled his impressions of this journey into some of his finest pictures: *Sunrise by the Sea, Chalk Cliffs on Rügen* and *The Sister on the Balcony by the Harbour*.

On the Sailing-Ship is perhaps the most personal of these pictures. Even though it is an artistically distanced double portrait, the biographical link is unmistakable. The couple on the sailing-ship are Friedrich and his young wife. The calm and emotional stability emanating from this picture permeated all Friedrich's work after his marriage: he repeatedly portrays people linked by love or friendship, in overpowering natural settings, depicted in a way that sets the mind racing and tempts us to dream.

"It is certainly tickles me to have a wife," wrote Friedrich to his family after the wedding. "It tickles me when my wife invites me to come to the table at midday. And in the end it tickles me too when I stay at home in the evening, all fine and dandy, and do not wander about outside as I used to. And it also tickles me that everything I now do is done with my wife in mind, and has to be done like that … In short, since I have changed I to We, a great deal has become very different. There is more eating, more drinking, more sleeping and more fooling about. And there is more money spent too, and perhaps in future we will have our share of worries … A number of things have changed in a number of ways since I have had a wife."

The devoted couple on the sailing-ship fascinated another recently married couple. In 1820. Nicolai Pavlovich, later Tsar Nicholas I, and his wife, Alexandra Federovna, née Princess Charlotte Louise of Prussia, visited Caspar David Friedrich in his studio and bought the painting. It now hangs in the Hermitage in St. Petersburg.

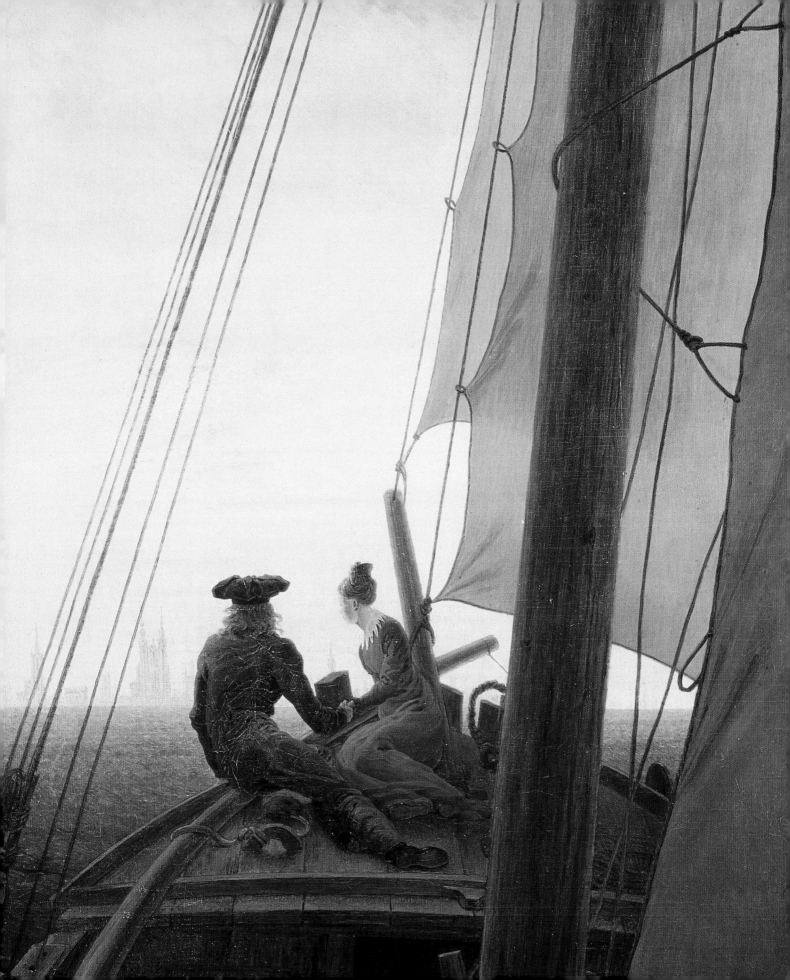

ADRIAN LUDWIG RICHTER

Bridal Procession in the Spring

Secure at your beloved's side, secure among friends and relatives, secure in the midst of nature. Every brushstroke in Ludwig Richter's *Bridal Procession in the Spring* breathes the ancient longing for life lived out in peace and heavenly harmony. There is no dark cloud on the horizon, man and the creation are one. Two young people seeking happiness have found each other and are walking with their wedding guests down a sunken lane from the marriage chapel to the meadow at the bottom of the hill. Two white doves are watching the group, children with wreaths in their hands and hair are hurrying ahead and scattering freshly picked flowers on the bridge. Ribbons and scarves flutter in the spring breeze, and we seem to hear the brook's exuberant gurgling. Golden light plays around the loving couple, one shepherd waves a greeting and a second is playing on his shawm. A fairy-tale idyll is being staged; in the real Germany, the first factories are being built and the change from an agrarian to a modern industrial society is well under way. In his search for simple things that are true and natural in the transitional period before the revolutions of 1848, Ludwig Richter finds a source in folklore. This painting, which is touching in its naïve and beguiling charm, seems like a folksong cast in paint. The people are wearing traditional German national costume, and the castle in the background is reminiscent of the Middle Ages. Richter got the idea for the picture from the world première of Richard Wagner's *Tannhäuser*.

The opera was first performed at the Hoftheater in Dresden in 1845, and Richter was so enthusiastic about the production that he immediately thought of using it for a picture. "Above all the final scene of the first act, when the sound of shawms and the shepherd's song greet the returning spring, with tolling bells and singing pilgrims welling up from afar, moved him so much as an artist that he tried to translate the musical and Romantic mood into a painterly one," wrote the Richter's son, Heinrich, about this picture. The fantasy of happiness, the dream of a whole and healthy world of simple people close to nature that this wedding picture exudes, is very close to Richter's fairy tale illustrations. And as in a fairy-tale, the bridal procession tells of the happy end of a love story. What follows, everyday life, is inappropriate material for an operatic and Romantic theme. What happened to 'happily ever after …? '

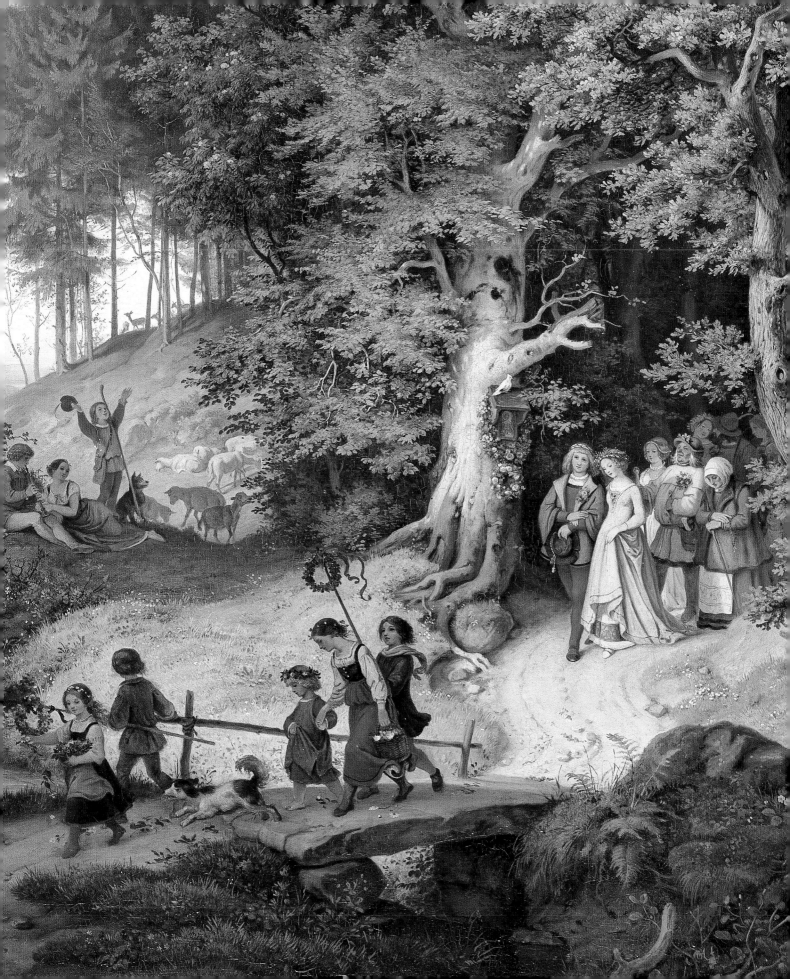

AUGUSTE RENOIR

Dance in the Town

The wedding ceremony is over and a magnificent party is about to begin. The bride and bridegroom are leading off the dancing, whirling across the parquet. For one long, happy and harmonious moment, everyday life and its darker side are forgotten.

Auguste Renoir loved to paint dancing couples, the epitome of *joie de vivre* and liveliness for him. Several works were produced in 1882 and 1883 showing couples moving in time with the music and in close physical contact: under trees in the open air, by the tables in the gardens of cafés and restaurants or in fashionable Parisian town houses. People can be themselves and transcend all kinds of social barriers when dancing. They can let themselves go to the rhythm, celebrate life unaffectedly and find their way back to an innocent paradise. At the time when this picture was painted, Renoir was greatly exercised by the question of what could be set against the meaningless emptiness of the mass industrial society. He rejects cultural pessimism in favour of the more cheerful side of life, and celebrates the beauty of women: "For me, a picture has to be loveable, pleasing and pretty, yes, it has to be pretty! There are enough displeasing things in the world, we certainly don't need to create any more," was his firmly held opinion.

When dancing, life is placed on an exceptional footing. And a wedding is perhaps the best opportunity to celebrate such an exceptional state of affairs. Renoir did not describe the elegant, exquisitely reticent couple any more closely. But in contrast with the more down-to-earth couples in the trippers' cafés outside Paris, the urban counterpart seems more distant, more withdrawn, and more rigidly controlled by social etiquette.

The young woman is floating across the floor on the tips of her toes, with her delicately made-up lips slightly parted. She is looking dreamily into nothingness. The delicate pink of the flower in her hair stands out from the rest of the picture, which is mainly in cool shades of green and blue, discreetly reinforcing her erotic charisma. Her right hand is resting on her partner's shoulder, and his face is almost completely covered. He is leaning slightly forwards – as if trying to whisper an intimate word in her ear. The greenhouse palm in the background and above all the couple's clothes lend the scene an air of elegance and nobility. The lively way in which the paint is applied and the lovingly detailed brushwork used to depict the woman's dress show how much Renoir admired rococo clothes. Renoir's great models for emphasis on fabric textures and the porcelain delicacy of skin are the rococo painters Fragonard and Boucher. His portraits of women invoke the classical role image: "Women do not think. They feel, and their knowledge – like that of children and animals – is intuitive."

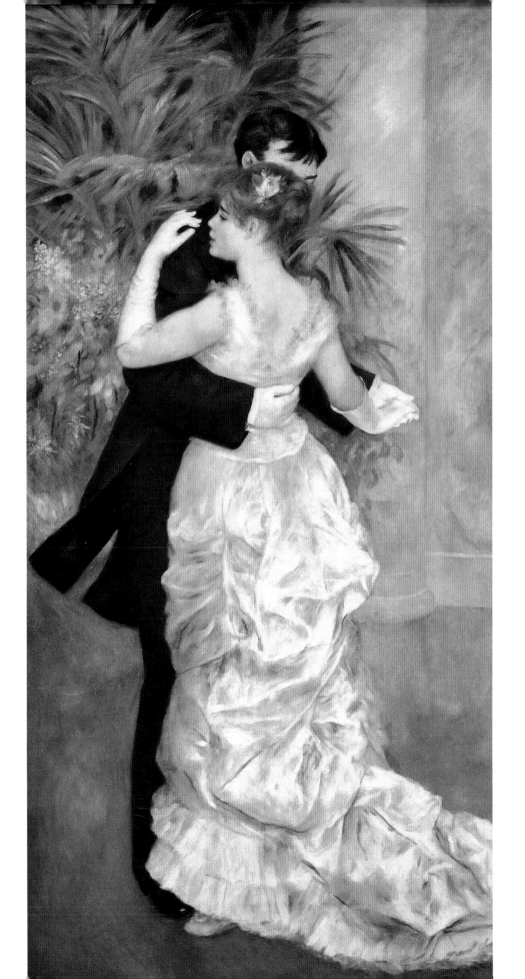

KASIMIR MALEVICH

The Wedding

The bride with the fiery red curls has found the man of her dreams. In a few minutes she will say "I will" to him in the church at the end of the bright path and start a new phase of her life. Golden ears of corn beckon the wedding party, birds and hedgehogs look on, the mood is cheerful and summery. It is only when one starts to try to establish clearly how the figures relate to each other that a remarkable feature emerges: all the men look the same! It is impossible to decide which of them is the bride's father or the groom, and who the other gentlemen are accompanying the young woman or holding her train, with their frock coats, curly beards and top hats. Only the colours differ, otherwise the men look as though they have been cloned. They are holding the flowers they have brought stiffly and form-ally, and the lines are so free and easy that the flowers could sometimes be plumes of cigar smoke. There are no women or children in this festive procession, which makes the bride even more powerfully erotic and attractive.

What Kasimir Malevich conveys in this 23 x 20 cm wedding miniature in pencil, water-colour and ink shows a gentle irony in terms of bourgeois rituals, and shifts between caricature, fairy-tale illustration and folk art. The brilliant theoretician of Modernism and inven-tor of the Black Square, the 'germ of all possibilities', is still operating in the tradition of symbolism and Jugend-stil here.

The picture dates from 1907, and is one of the so-called White Series, in which Malevich took a sharp look at bourgeois society, which was inclined towards elegant feasts and distractions of all kinds in the years before the October Revolution. His resources are chosen with conscious naïveté, and his use of the less over-powering primary colours, the two-dimensional and decorative handling of the picture space and the almost childish floral decoration on the bride's train show how intensively Malevich was trying to come to terms with the aesthetic postulates of Jugendstil. But the young Malevich was also impressed by Russian folk art, the devotion with which the peasants used their simple resources to decorate walls and stove tiles, and this put the idea of being an artist into his head. He spent his youth in the country, and the impressions he gained there affected him throughout his life; this showed up again and again in a whole variety of creative phases. He wrote in his autobiography: "… horses, flowers, cock-erels on primitive wall frescoes and wooden sculptures. I noticed a certain connection between peasant art and the art of icons: the art of icons is peasant art in a higher form. I discovered the spiritual side of the peasant epoch in this art. The icons taught me to understand the peasants."

The hedgehog and the birds, the flowers in the men's hands, are Malevich's affirmation of the primitive revival that the art theory of the day saw as the basis of social reform running across all classes. However en-chanting the bride may look, her stiff, bourgeois escorts are clearly not representatives of a reformed, forward-looking society.

GUSTAV KLIMT

The Kiss

Everything is forgotten for a moment. Past, present and future mingle in a single tidal wave of emotion. Two people entangled in the Utopia of romantic love, distilled into an image. A golden aureole surrounds the couple, who have sunk to their knees. Their clothes, glowing gold, fall loosely and merge into each other. The two lovers lie in each other's arms, freed from the suffocation of social constraint. The woman abandons herself to the kiss utterly, with her eyes closed. Her dress has slipped off her shoulder, one of her hands is round her lover's neck, the other is trying to touch his hand. He is leaning over her, holding her head tenderly with both hands. The kiss has become an icon for all those addicted to love who dream of melding I and You.

Klimt uses the language of the hands and the sparingly revealed areas of skin to charge the scene with lascivious sexuality. The Byzantine ornamentation on the clothes and the wreaths in the couple's hair bring this lovers' dream to the pinnacle of perfection. The patterns of flowers and circles on the woman's dress reflect the patterns in the flower-meadow. The man's clothing

is more austerely designed in terms of both form and colour, with a hint of the reform movement in the long black, grey, brown and white rectangles. This is young love, bedded on a sea of flowers. And at the same time they are in danger of falling. The painter places the couple over an abyss, subtly and sensitively. The woman is on the edge of a cliff, the blossom-covered rock is falling into the depths beneath her. The dream of true love is extended into a dream of love that is free and in danger. The picture was painted in Vienna at the turn of the nineteenth to the twentieth century: the current sexual roles have started to shift, women are discovering their bodies and their sexuality. The new Eve is aware of her feminine charms, and strikes fear into men as a *femme fatale* and man-eating sphinx. Bourgeois marriage values are being questioned. The pyschoanalyst Otto Gross is campaigning for uninhibited love, liberated from the fetters of marriage, and free of jealousy. Otto Weiniger uses both his book and his gender to label woman as dark abysses, waiting to devour men. Klimt lived his life as an artist beyond the norms of bourgeois society. After his death, fourteen demands for maintenance were submitted to his estate, most of them from 'sweet girls' who had sat for him as models. Klimt's love for the milliner and dressmaker Emilie Flöge, was platonic. Emilie was not just the person who was central to his emotional life, she also helped with his work. But for all his liberality and open-mindedness, Klimt had difficulty in ridding himself of the traditional image of men and women. The couple's relationship in *The Kiss* is clearly defined. The woman seems to have been poured into the figure of the man as far as the composition is concerned. She remains subjected to him. Everything stays just as it always has been – in free love as well.

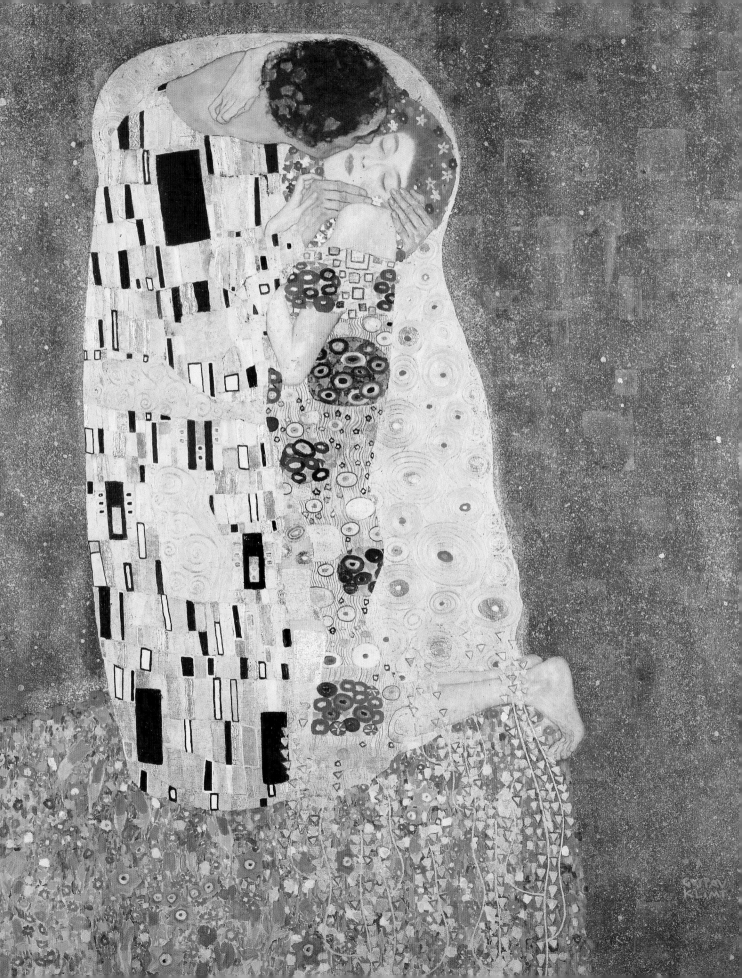

EGON SCHIELE

Love-Making

Two lumps of flesh, clamped tightly together. The man and woman are staring at the viewer with a cold, trance-like eye, making him or her into a voyeur at an intimate scene. Their eyes are empty, their cheeks pale, their faces pale as death. The couple are like two vampires who have sunk their fangs into each other and are sucking out the life-blood in a greedy fight for redemption and rescue, and perhaps also for a spark of genuine feeling.

Inflamed, fleshy, bloody red is the dominant colour of the drawing with its expressive, linear strokes. It does not show a romantically transfigured, soft-focus moment, but the animal, compulsive side of sexuality, which was equally

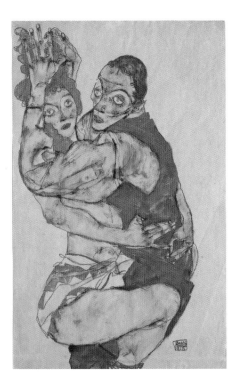

fascinating to psychology, medicine and art around 1900. In *Love-Making* Schiele depicts unleashed physical passion to make the depths of modern existence visible and tangible.

The expressions on the couple's faces, which contrast strikingly with the fusion of their bodies, suggest profound loneliness and unsatisfied hunger. "The act of love is very similar to torture or to a surgical operation," wrote the French Symbolist Charles Baudelaire, who was a major influence on the artists of Viennese Modernism, including Schiele. There is nothing happy, vital or natural in this nakedness and intimacy. Here, two people tearing each other to pieces, rather than making each other happy. When Schiele drew this nude study in 1915, its directness was seen as pornographic and scandalous. Even at the time, friends of the artist pointed out that there was no help for people who saw nothing but nakedness and obscenity in his work. Today, as we are used to the sight of copulating couples on TV and at the cinema, and there is no sense of a taboo being broken, this picture's suggestion of mutual suffering is more easily perceived. Schiele was concerned to make people aware of repressed sexuality in bourgeois *fin-de-siècle* society. But today, the couple's fatal entanglement is more strikingly obvious: anyone who seeks relief, even physically, in love will remain eternally driven and unsatisfied. "The lie about relief asserts that all one needs to do is find the right partner, and then every need will be permanently fulfilled with each other – whether that need is intellectual, emotional or erotic," says the distinguished marriage guidance counsellor and writer Michael Mary. The consequences of this expectation are well known. Partners are changed frequently; the partner is constantly criticized and there are endless attempts to change him or her; constant power struggles, discontent and grumbling."

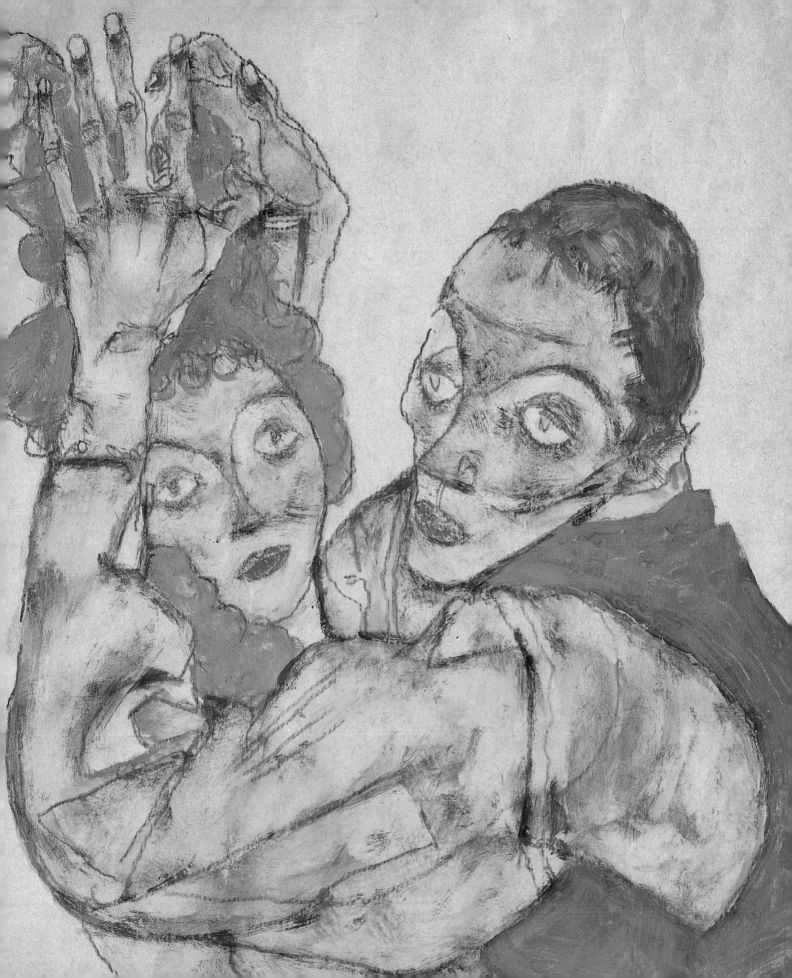

GRANT WOOD

American Gothic

What is left of love after twenty years of eating your breakfast porridge together, hard work on the farm, growing debt, dwindling topics of conversation, faded passion and constant, debilitating minor skirmishes about character defects large and small? Wood casts a cool and objective eye over scenes from a provincial American marriage, condensed to a moment of universal validity. The woman has lost all her charm. Her features are care-worn and she seems disillusioned. She is looking past her husband into the distance; she does not have much more to say to him. All hope of a happy life together has long gone. What remains is doing one's duty and accepting the fate that God has determined. The husband is also calmly aware of the reality of the situation as he holds his fork firmly on the ground, making it look like a shield between the outside world and the home of his own that he has struggled to bring into being. His sensuality is throttled by the tight collar on his striped shirt, and his wife is similarly encumbered by her meticulously neat white collar. He is wearing a black Sunday jacket over his working clothes, living his life between work and church. These two poles run through the whole composition like a thread. They are reiterated in the woman's black Sunday dress, which is protected by a sleeveless overall, and in the Gothic window of the farmhouse, which gives the picture its title.

This portrayal of two settlers created a stir when it first appeared, and made Wood famous overnight. This oil painting, which borrowed from the style of the fifteenth century Flemish masters, was seen from the outset as a satire on the puritanical values of the rural Midwest. But Wood, who had seen the house with a Gothic window in a small town in Iowa and immortalized it in "American Gothic," resisted the suggestion that he had shown only the narrow-mindedness and sadness of Midwestern culture. He said that he had also intended his picture to show the dignity of the farmers in their closeness to nature, and that ultimately he was part of this culture himself.

"The people I was thinking of when I painted this picture are small-town dwellers rather than farmers," he wrote to a female art-collector friend. "The man manages the local savings bank or perhaps the timberyard. He is an important person in the church congregation, and perhaps even preaches from time to time. He comes home from work in the evening, takes his collar off, slips into his working overall and goes into the barn to feed the cows. His wife is very self-righteous, just as he is. I saw to it that there was a strand loose in her hair-do to show that she is human – despite everything … I think that these people are fundamentally decent and good." Wood tries to capture the settler ideal and everyday American life very precisely. He felt that making use of local colour would save American painting, indeed bring about its renaissance. He was sceptical about the early days of abstract art. He asked his dentist and his sister to pose as models for *American Gothic*, in the style of the Old Masters. He explained later that he wanted to show a father and his daughter, but the picture was seen and interpreted as a portrait of a married couple from the outset.

Frida and Diego Rivera

What does marriage mean in an age when bourgeois conventions mean so little? Is it anything more than an agreement about keeping warm and fed and founding a family, so that possessions and work can be passed on to the next generation? The biography of the married Mexican painters Frida Kahlo (1907–54) and Diego Rivera (1886–1957) is a possible response to the challenges that modern relationships face.

This was a shared life that could scarcely have been more turbulent or emotionally explosive. Passion and profound emotional attachment from the outset. Marriage, divorce, re-marriage, sexual escapades throughout their lives – some with members of their own sex. Unable to do without each other despite being completely independent in terms of character, artistic temperament and money. A passion that brought happiness, but also profound despair, loneliness and psychological agony. Kahlo in particular, behind the façade of the superior, proud woman, who openly used her sexual charms, suffered from Rivera's infidelity throughout her life. And she also kept her own love affairs secret, so as not to provoke her husband's jealousy.

The picture *Frida and Diego Rivera*, painted two years after they were married, suggests little of the storms that were to come. Kahlo appears in the classical Mexican role of the submissive wife at the side of a powerful man. Rivera is made to look bigger and more opulent than he was in reality. He is holding his palette as a sign of artistic success and the social status he acquired as Mexico's most famous mural painter of the day. Kahlo paints herself at his side looking small and dainty, in need of love and affection. Her tiny feet almost disappear alongside his enormous miner's boots.

Compared with later depictions, this double portrait seems somewhat stiff and conventional. Kahlo kept returning to Rivera as a subject for her art. Many of the pictures can also be read as a personal history of a marriage that was bound to change, but had its constants as well. In this early portrait of the couple, Kahlo still sees herself as a daughter. She will later present herself as a mother, cradling her husband in her arms like a baby. Between these are self-portraits after their divorce in 1940, in which she appears with her hair cut off and men's clothes, or with a monkey as a substitute lover.

She met Rivera, twenty years older and twice married, in the Mexico City Communist Party when she was twenty-one. The mutual attraction was as spontaneous as it was profound. A similar sense of humour, lively minds, social commitment, thoroughly un-bourgeois ideas about morals, openness to everything that life has to offer and, above all, mutual respect for artists' work were the foundations on which the relationship was based, despite recurrent hostilities, until Kahlo's death in 1954.

In 1939, the marriage was dissolved at Rivera's suggestion. His ex-wife Lupe Marín, with whom he had two children, may have contributed to the break-up just as much as his affair with Kahlo's favourite sister, Cristina. Kahlo's relationship with the American photographer Nick Murray and her long periods abroad in Paris and New York also contributed to the break-up "I have been involved in two major accidents in my life," Kahlo wrote later. "One was when I was run over by a tram, the other is Diego." The couple remained in touch even after the divorce. Her doctor brought about a reconciliation late in 1940: Rivera himself asked her to marry him several times before she agreed for a second time.

MARC CHAGALL

Bridal Couple with Eiffel Tower

True love – who has ever painted it as feelingly and uncompromisingly as Marc Chagall? His lovers float through space as if in zero gravity, far from reality, immersed in celestial bliss. It does not matter what is happening around them, they shall have music wherever they go, played on celli and double basses in this case. The magic of mutual attraction, the harmony of souls and never-ending fascination with each other, Chagall captures all this in his poetic, fairy-tale images. There are no rifts in his cosmos, no questioning of major emotions. The irresistible power of love is victorious over the rest of the world.

Bridal Couple with Eiffel Tower is one of a long series of lovers and couples at weddings that played an important part in Chagall's oeuvre. Again and again he painted couples in tight embraces, and most of them are recognizable as Chagall himself and his first wife, Bella Rosenfeld.

Bella, whom he met in 1909 in his Russian home town of Vitebsk and married in 1915 after his first stay in Paris, came from a well-to-do family, was an actress and had studied literature and philosophy. They shared an enthusiasm for theatre and art, and an affection that stayed with them throughout their lives.

Experience of personal happiness and the fact that his dream of a great love came true had a direct effect on Chagall's art. Chagall first painted the motif of a couple floating in the air in *The Birthday*, painted in the year he got married. Bella described the birthday encounter like this in retrospect: "Suddenly you lifted me off the floor and pushed yourself off with one foot, as though there was not enough room for you in this confined space. You launched yourself into the air, stretched out to your full length and floated along the ceiling. Your head was on one side, and so you turned my head round as well …"

Bridal Couple with Eiffel Tower dates from 1938/1939 and once more conjures up the happy years that Marc Chagall and his wife spent in Paris and France between 1922 and 1941. Paris had become Chagall's second home. The Eiffel Tower, and Paris' boulevards and rows of houses crop up again and again in his painting, which flicker somewhere between dream and reality. The bridegroom is holding his bride tenderly, and the couple are surrounded by angels, flying towards heaven or shooting downwards. The animals, a larger-than-life-size cockerel and a he-goat symbolize the link between God, nature and man. On the lower right-hand side of the picture is a village setting, Chagall's constantly recurring reminiscence of his childhood in the Russian ghetto. Chagall had painted a 'Bridal Couple with Eiffel Tower' before, in 1928. Ten years later, the cheerfulness and light-hearted atmosphere are under threat. In the left-hand section of the picture, the couple can be seen under a baldacchino, with a sea of annihilating flames flickering behind them. Chagall painted this wedding picture shortly before the outbreak of World War II brought the carefree Paris days to an abrupt end. The couple emigrated to the USA, where Bella died in 1944 as a result of careless treatment in hospital.

MAX ERNST

Dressing the Bride

Anyone getting married is bound to have a sense of embarking on an adventure, but with a reasonably clear idea of what life with the intended partner will be like. But what happens in the subconscious, the place that all the plans and ideas cannot reach? Perhaps the best day of your life won't be a glorious dream, but the beginning of one long nightmare …

A Surrealist like Max Ernst is interested in what happens beneath the surface of bourgeois conventions such as weddings. A marriage may been seen as complete acceptance of the prevailing social order, but *Dressing the Bride* draws attention to the darker sides and dissonances that are part of any order that is supposed to be safe and secure. The bridal chamber he allows us to glimpse is a fascinating chamber of horrors, terrible and beautiful at the same time. Rather than being chastely dressed in white, the bride is wearing provocatively

erotic blood-red. Her dress is a robe-like feather cloak that is in itself a demonstration of power, reminiscent of the ermine-trimmed robes of queens and empresses. And this ostentatious garment revels everything that is usually concealed. The woman's body is naked and seductive, but her head and face are hidden under the head of a bird of prey that is fixing the viewer with a beady and threatening glare. A lecherously grinning mask is perched on her breasts. One of the bride's eyes is looking out of the bird-hood, past another woman and on into empty space. The bird-dominatrix is pushing this other woman aside with a resolute, potentially violent gesture. Is this her alter ego before the wedding? Her bridesmaid? Her rival? That – like everything else in this picture – remains mysterious and equivocal, beyond reason, but still triggers several chains of association. And that is exactly what Max Ernst wanted to do: open up spaces for the imagination. He was always vehemently opposed to precise interpretation of his pictures.

We are not seeing a romantically transfigured preparation for a bed of roses here; a great deal points to conflict, pain and injury. The green swan-creature who is presenting the bride with a sharp arrow or even threatening her with the weapon, the weeping hermaphrodite, the woman with the fan-like hairstyle, raising her hands to show that she is unarmed or to fend off suffering, all this is profoundly distressing and disturbing. Anyone who embarks upon the marriage adventure also conjures up dark spirits that he or she did not want to invoke – that seems to be the message of this picture. But it is also seductively beautiful – precisely because of the chasms that it opens up.

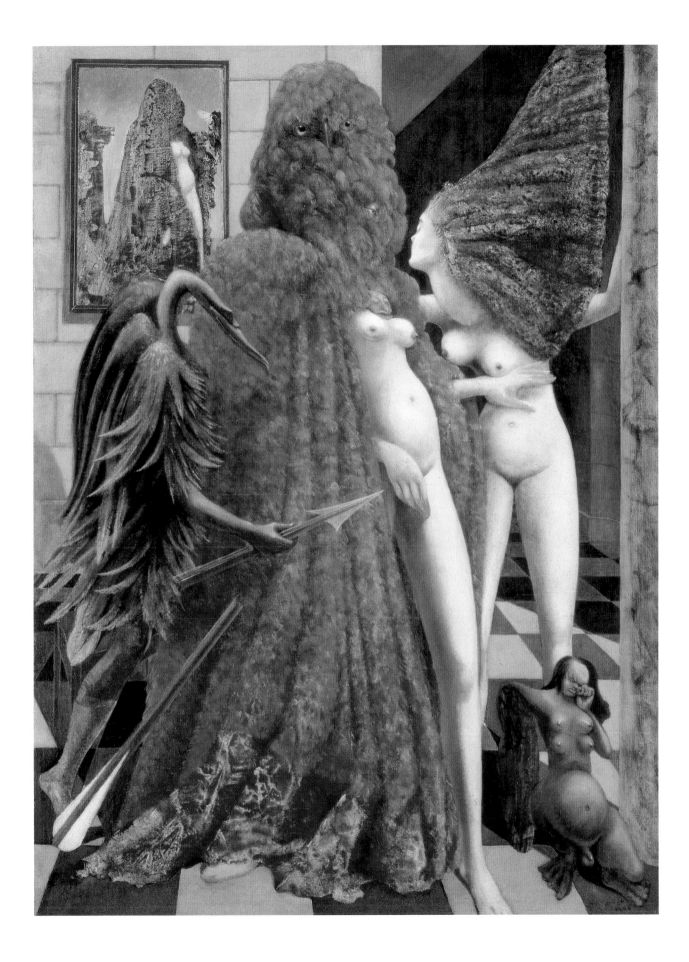

ROY LICHTENSTEIN

The Kiss

The plane's propellers are turning, the couple will soon be separated. Goodbyes on the runway, Casablanca everywhere. A gorgeous, perfect couple. His hair is so black, his grip so powerful and so firm. She snuggles as close to him as she can. Long blond hair, red lips, red fingernails, red dress. The screen-print dots and the brushstrokes breathe a fervent sigh. The emotional brakes are completely off – too much so, as the scene seems kitschy and trivial. Roy Lichtenstein takes full advantage of the cheap eroticism of advertising, magazines and films, tests them to destruction for emotional validity and thus reduces them to absurdity. The man and woman fit in with current ideals of beauty, and yet remain remarkably sterile. They are icons of the consumer society with their prefabricated dreams. The I-You Utopia is subtly deconstructed here. The couple are entirely wrapped up in their own narcissistic feelings. No more eye contact, no more devoted stares.

Even the kiss is indirect. He is kissing her neck, not her perfectly made-up lips. Dior Number 12 was not meant to be touched. What we see is a moment of self-obsessed concentration on Hollywood-style sentiment. Lichtenstein contrasts the triviality of the subject with a reduced, almost cool formal vocabulary. The colour palette is reduced to the primary colours red, blue, yellow, allied with some black and white contrasts. The screen dots and brushstrokes are adapted to the stereotyped, mechanical formal language of the industry. This gives the scene a particularly banal quality. Lichtenstein is interested in the lack of sensitivity that pervades modern society, in the brutalization, deadening and loss of sensibility in amorous and other emotional matters. "We live in a world in which emotions are allowed to develop, but nothing becomes really emotional. It is this conventional, stereotyped and ultimately empty emotion that I am trying to show."

PABLO PICASSO

Matador and Nude

Painting and love, procreation and creative work: these are one and the same thing for Picasso. He is an almost archetypal embodiment of the myth of the artist who is constantly sacrificing fresh female flesh on the altar of art to fuel his inspiration. He had five different partners, four children by different women, many mistresses and created a sea of howling misery that crashed through the generation barrier. "Do creative people have the right to destroy everyone who is close to them and drive them to despair?" Picasso's granddaughter Maria from his first marriage, asked again recently in her memoirs *But Still a Picasso*. Any personal recollections by women from the painter-genius's circle show Picasso as the magic centre of a musical box with a lot of moving figures on the top: he simply winds them up and lets them circle round him.

Olga Koklova, whom Picasso met when she was dancing with Diaghilev's Ballet Russe and married a year later, never got over their separation, refused to divorce him, wrote to him every day, and went through phases of pursuing him jealously, almost obsessively, night and day. Dora Maar, the dark, mysterious, esoteric Surrealist photographer had a nervous breakdown when Picasso left her. Marie Thérèse Walter, Picasso's blond, sensual, doe-eyed mistress from 1927, committed suicide in 1977. Jacqueline Roque, forty-five years younger than Picasso and his last partner, shot herself in the house they had shared, thirteen years after he died. Only the painter Françoise Gilot, with whom Picasso lived from 1946, managed to escape from his all-consuming emotional force-field: she left him in 1954 and started anew.

New wife, new home, new friends, new dog, new creative phase. This pattern runs through Picasso's life like a thread. He portrayed many of the women in his life in different styles. Always alone, never with him. Thus, there are very few portraits of couples in his enormous oeuvre – when they do crop up they are usually treatments of the painter-model theme. The personal emotional entanglements start to make their presence felt from the mid-twenties, but always as rather formal motifs. Nervous, angular lines in the portraits of Dora Maar, rounded, soft ones in the Marie-Thérèse Walter works. He distorts, fragments and depersonalizes his figures, influenced by the poetry of Georges Bataille, which deals with cruelty, ritual, sacrifices, self-mutilation and suppressed animal instincts. Shattered feelings need shattered forms.

In the work of his old age, in the drawings in particular, we find a sudden accumulation of couples locked in embraces with each other, apparently happy, as though the artist, by then in his eighties, is trying to keep death at bay by invoking eroticism and sexuality. He produced some wonderfully light, happy images in this period, like the nude study shown here. The battle of the sexes is transformed into a hymn to life and love.

But Picasso's late work was not a happy ending, revelling in perfect love. He produced drawings and paintings at the same time as the pictures of couples that tell the story of two people being lonely together. Or of the woman striking a desirable pose in her own interest, her nakedness then confronting the man's weary sense of *déjà vu*.

JEFF KOONS

Jeff and Ilona

Love is luscious and lascivious. Love can start with a French kiss. Love is hardcore: Ilona in bridal-white lace stockings and a lace bodice on top of Jeff. Jeff in Ilona, with her black suspenders and stilettos. Pornography? No, this is art. In his 1991 series 'Made in Heaven,' Jeff Koons, king of art kitsch, is setting the genitals to work at getting rid of 2000 years of Western Christian tradition. Liberation from guilt and shame – this is a suitable artistic theme for Koons, who grew up in puritanical America. He set out to find for popular images for the twenty-first century that could express everybody's dreams and longings. He found the material for his 'Made in Heaven' series in porn films, and his star in porn queen Ilona Staller ('Cicciolina'). Penetration and ejaculation in every possible position are photographed, then captured in oil paint on canvas, cast in Murano glass or plastic and set up in exhibition galleries, along with carved and painted artificial flowers or kitschy puppies. This – deliberately – reduces eroticism to sterility.

You can think what you like about these works, which have a whiff of scandal about them. But the radical way in which Koons the artist makes himself into an object of desire and voyeurism reveals that he is both a romantic and a moralist at heart. He makes use of these hollow images, digs his way through the shallow emotional garbage to find the last traces of genuine feeling and true love in the corners. Eroticism, sex, artificial emotions, religious and mythological motifs, cute little fragments from the entertainment and advertising industries reduced to the status of knick-knacks – all this is mixed up together and viewed from a meta-plane. "When sexuality is associated with love," Koons explained in an interview with Anthony Haden-Guest, "a higher plane, and objective plane is reached, and you get in touch with eternity. And I think that's just what I give my viewers. It's not pornographic, because love was involved."

Intimacy and the public sphere merge, in art as in real life. Koons married his Cicciolina in 1991. Jeff and Ilona as the Adam and Eve, the Dionysus and Ariadne of our day. "I don't have anything to do with pornography. Pornography is a representation of the sexual act. I'm really not interested in it. I'm interested in love, in people getting back together, I'm interested in spiritual things, the ability to show other people that they can have influence, that their dreams can come true."

Unfortunately, earth caught up with what had been made in heaven. The marriage was dissolved after the birth of the son they had together, and a bitter custody battle ensued. For the time being, 'Made in Heaven' works cannot be illustrated or reproduced. The up-to-date Adam and Eve story is consistently modern in this respect as well.

Index of Plates

Page 25 Giotto, *The Wedding of Mary and Joseph*, *c.* 1305, detail from the fresco cycle, Arena Chapel, Padua

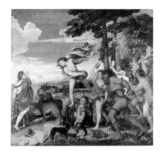

Page 31 Jan van Eyck, *The Arnolfini Marriage*, 1434, oil on wood, 81.8 x 59.7 cm, National Gallery, London

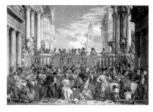

Page 37 Titian, *Bacchus and Ariadne*, *c.* 1522–23, oil on canvas, 175 x 190 cm, National Gallery, London

Page 43 Paolo Veronese, *The Wedding at Cana*, 1562/63, oil on canvas, 666 x 990 cm, Musée du Louvre, Paris

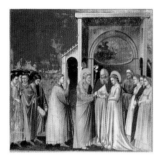

Page 27 Unknown master, *Gotha Lovers*, *c.*1480/85, oil/tempera on panel, 118 x 82.5 cm, Schlossmuseum Gotha

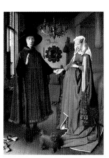

Page 33 Piero della Francesca, *Federico da Montefeltro with his wife Battista Sforza*, *c.* 1472, tempera on wood, each panel 47 x 33 cm, The Uffizzi Gallery, Florence

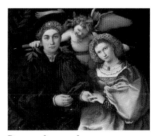

Page 39 Lorenzo Lotto, *Wedding Portrait of Marsilio and his Bride*, 1523, oil on canvas, 71 x 84 cm, Museo del Prado, Madrid

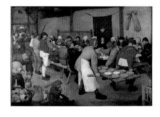

Page 45 Pieter Bruegel the Elder, *The Peasant's Wedding*, *c.* 1568, oil on panel, 114 x 164 cm, Kunsthistorisches Museum, Vienna

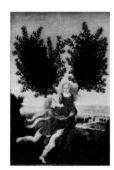

Page 29 Antonio del Pollaiuolo, *Daphne and Apollo*, *c.* 1470–80, oil on panel, 29.5 x 20 cm, National Gallery, London

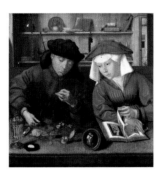

Page 35 Quentin Massys, *The Banker and his Wife*, 1514, oil on wood, 71 x 68 cm, Musée du Louvre, Paris

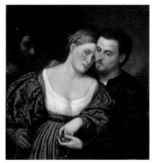

Page 41 Paris Bordone, *The Couple*, *c.* 1525, oil on canvas, 80.5 x 85 cm, Pinacoteca di Brera, Milan

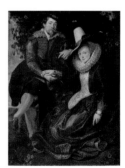

Page 47 Peter Paul Rubens, *Rubens and Isabella Brant in the Honeysuckle Arbour*, *c.* 1609, canvas and oak, 178 x 136.5 cm, Bayerische Staatsgemäldesammlung, Alte Pinakothek, Munich

Page 49 Frans Hals, *Lucas de Clercq and Feyntje van Steenkiste*, c. 1635, oil on canvas, 126.5 x 93 cm and 123 x 93 cm, Rijksmuseum, Amsterdam

Page 55 Antoine Watteau, *Le Faux Pas*, 1717, oil on canvas, 40 x 31.5 cm, Musée du Louvre, Paris

Page 61 Jean-Honoré Fragonard, *The Stolen Kiss*, c. 1788, oil on canvas, 45 x 55 cm, Hermitage, St. Petersburg

Page 67 Adrian Ludwig Richter, *Bridal Procession in the Spring*, 1847, oil on canvas, 93 x 150 cm, Gemäldegalerie Neue Meister, Dresden

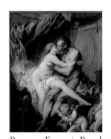

Page 51 Rembrandt, *Rembrandt and Saskia*, c. 1636, oil on canvas, 161 x 131 cm, Gemäldegalerie Alte Meister, Dresden

Page 57 François Boucher, *Hercules and Omphale*, c. 1730, oil on canvas, 90 x 74 cm, Pushkin Fine Arts Museum, Moscow

Page 63 François Gérard, *Cupid and Psyche*, 1798, oil on canvas, 186 x 132 cm, Musée du Louvre, Paris

Page 69 Auguste Renoir, *Dance in the Town*, 1883, oil on canvas, 180 x 90 cm, Musée d'Orsay, Paris

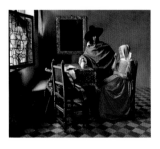

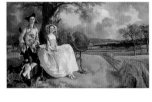

Page 53 Johannes Vermeer, *The Glass of Wine*, c. 1658–60, oil on canvas, 65 x 77 cm, Staatliche Museen zu Berlin – Preußischer Kulturbesitz Gemäldegalerie, Berlin

Page 59 Thomas Gainsborough, *Mr. and Mrs. Andrews*, c. 1749, oil on canvas, 69.8 x 119.4 cm, National Gallery, London

Page 65 Caspar David Friedrich, *On the Sailing-Ship*, c. 1818/19, oil on canvas, 71 x 56 cm, Hermitage, St. Petersburg

Page 71 Kasimir Malevich, *The Wedding*, 1907, watercolour, ink and pencil on paper, 23 x 20 cm, Museum Ludwig, Cologne

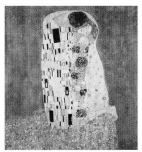

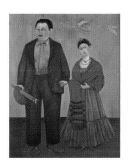

Page 73 Gustav Klimt, *The Kiss*, 1907/08, oil on canvas, 180 x 180 cm, Österreichische Galerie Belvedere, Vienna

Page 79 Frida Kahlo, *Frida and Diego Rivera*, 1931, oil on canvas, 100 x 79 cm, San Francisco Museum of Modern Art

Page 85 Roy Lichtenstein, *The Kiss*, 1962, oil on canvas, 203.2 x 172.7 cm, David Geffen Collection, Los Angeles

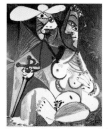

Page 75 Egon Schiele, *Love-Making*, 1915, pencil and gouache on paper, 33.5 x 52 cm, Leopold Museum, Vienna

Page 81 Marc Chagall, *Bridal Couple with Eiffel Tower*, 1938/39, oil on canvas, 148 x 145 cm, Centre Georges Pompidou, Paris

Page 87 Pablo Picasso, *Matator and Nude*, 1970, oil on canvas, 162 x 130 cm, Sammlung Berggruen, Berlin

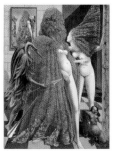

Page 77 Grant Wood, *American Gothic*, 1930, oil on hardboard, 74.3 x 62.4 cm, The Art Institute of Chicago and VAGA, New York, Friends of American Art Collection

Page 83 Max Ernst, *Dressing the Bride*, 1940, oil on canvas, 129.6 x 96.3 cm, Peggy Guggenheim Collection, Venice

Page 89 *Jeff and Ilona*, 1991, photograph: Peter Schinzler

Photographic credits

All pictorial material has been kindly supplied by the museums and private owners or has been taken from the Publisher's archive or the author's, with the exception of:

AKG Berlin pp. 39 and 93, 65 and 94, 69 and 94
AKG Berlin/Erich Lessing pp. 41 and 93, 43 and 93, 45 and 93, 55 and 94, 61 and 94, 63 and 94
© The Art Institute of Chicago pp. 77 and 95
Artothek, Blauel/Gnamm p. 11
Bildarchiv Foto Marburg pp. 27 and 93
© Bildarchiv Preußischer Kulturbesitz, Berlin 2001,
Photos: Jörg P. Anders pp. 53 and 94
Joachim Blauel/Artothek pp. 47 and 93

The Solomon R. Guggenheim Foundation, Venice pp. 83 and 95
Fotostudio Otto, Vienna (front cover), pp. 73 and 95
Klut, Dresden pp. 51 and 94
© Museo Nacional del Prado, Madrid (frontispiece)
© National Gallery, London pp. 17, 19, 29 and 93, 31 and 93, 37 and 93, 59 and 94
H. & A. Pfeifer, Vienna pp. 75 and 95
Rheinisches Bildarchiv Köln, Cologne pp. 71 and 94
Sächsische Landesbibliothek, Dresden, Abteilung Fotothek,
Photos: R. Richter pp. 67 and 94
© San Francisco Museum of Modern Art, San Francisco pp. 79 and 95
Photo: Peter Schinzler/Agentur Anne Hamann pp. 89 and 95

Front cover: Gustav Klimt, *The Kiss*, detail (see p. 73)
Frontispiece: Hieronymus Bosch, *The Garden of Earthly Delights*, 1480–90, oil on panel, triptych 220 x 195/390 cm, Museo Nacional del Prado, Madrid
Page 91: Pablo Picasso, *Couple*, 1971, coloured pencils, felt pen and pastel on paper, 31 x 24.5 cm. Private collection

Die Deutsche Bibliothek CIP-Einheitsaufnahme data and the Library of Congress Cataloguing-in-Publication data is available

© Prestel Verlag, Munich · Berlin · London · New York 2002

Prestel Verlag
Mandlstrasse 26, 80802 Munich
Tel. +49 (89) 38 17 09-0
Fax +49 (89) 38 17 09-35

4 Bloomsbury Place, London WC1A 2QA
Tel. +44 (020) 7323-5004
Fax +44 (020) 7636-8004

175 Fifth Avenue, Suite 402,
New York, NY 10010
Tel. +1 (212) 995-2720
Fax +1 (212) 995-2733

www.prestel.com

Translated from the German by Michael Robinson, London
Edited by Christopher Wynne

Design and layout: Ulrike Schmidt
Origination: Repro Ludwig, Zell am See
Printing: Sellier, Freising
Binding: Conzella, Pfarrkirchen

Printed in Germany on acid-free paper

ISBN 3-7913-2527-2